HOW TO DRAW
CARTOON BABY ANIMALS
CHRISTOPHER HART

WATSON-GUPTILL PUBLICATIONS/NEW YORK

To all my readers—
those who've never read my books before
and those who've come back for more

Senior Editor: Candace Raney
Project Editor: Alisa Palazzo
Designer: Bob Fillie, Graphiti Design, Inc.
Production Manager: Ellen Greene

Front and back cover illustrations by Christopher Hart
Text and illustrations copyright © 2000 Christopher Hart

First published in 2000 by Watson-Guptill Publications,
a division of BPI Communications, Inc.,
1515 Broadway, New York, N.Y. 10036

Library of Congress Cataloging-in-Publication Data
Hart, Christopher.
 How to draw cartoon baby animals / Christopher Hart.
 p. cm.
 Includes index.
 ISBN 0-8230-2369-9 (pbk.)
 1. Cartooning—Technique. 2. Animals—Infancy—Caricatures and
cartoons. I. Title.
NC1764.8.A54 H38 2000
743.6'9139—dc2 99-056350

Printed in Singapore

First printing, 2000

1 2 3 4 5 6/ 05 04 03 02 01 00

CONTENTS

INTRODUCTION

I've written many books on cartooning in order to help the aspiring artist, animator, and cartoonist. And while this book contains an array of new characters and important techniques, it's also just plain old good fun.

Whenever you see a popular animated feature film, chances are that at least one of the star characters will be a young animal. It's a surefire way to bring an audience into a story. Comic strips, too, abound with young animals, as do children's storybooks, computer games, toy design, and advertising. Baby and youthful animals are an obvious and essential part of any cartoonist's repertoire, but drawing these characters is also something that most beginners avoid because it's difficult to do.

Why is this? Two reasons. First, while it's easy to draw something funny or cute, it takes specific knowledge to render a subject a particular age. Second, many people are only fleetingly familiar with the structure of most adult animals and are not well versed

enough to transform that knowledge into younger interpretations of the same. In addition, baby and young animals are *not* miniature versions of their adult counterparts; they are quite different. And these differences are what make them so cute and adorable. If drawing young animals was simply a matter of drawing a smaller adult animal, then we wouldn't be able to distinguish short animals from babies, which is not the case.

This book will help you understand the basics of baby animal anatomy and apply it to your drawings. It will give you an overview of the important principles of drawing and character design, and it will also show you how to draw a wide variety of animals. There are bear, lion, and tiger cubs; baby elephants, rhinos, and hippos; foals, bunnies, and piglets; baby birds, beavers, and monkeys; puppies, kittens, and baby mice; baby dolphins, sharks, and alligators; and much more. Plus, there are several types of each animal included. So, sharpen your pencil, turn the page, and let's have fun.

BABY ANIMAL BASICS

For cartooning purposes, baby animals refer to *young* animals, which are the equivalent of human toddlers and children. Baby animals are seldom represented as newborns, because in the animal kingdom, baby animals must grow up quickly to avoid predators; nature dictates that most animals learn to walk or swim immediately after, or within hours of, birth.

The Baby Animal Head

To begin drawing a baby animal, start with the head. The example here shows a bear cub, but these basic principles apply to drawing any type of young animal.

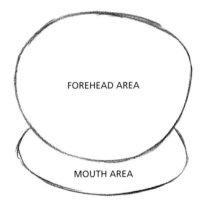

FOREHEAD AREA

MOUTH AREA

Notice that the top part of the head is much bigger than the bottom part. This is the most important thing to remember about drawing baby animal heads.

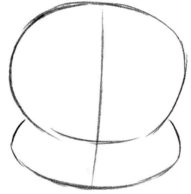

Next, add a vertical guideline to help you evenly position the features on the head. This is called the centerline, and it divides the head down the middle. The line formed where the forehead and mouth areas meet provides a perfect horizontal line.

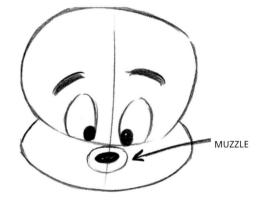

MUZZLE

Evenly place the eyes on either side of the centerline, also resting them on the horizontal line. Add the muzzle or nose. Note that the muzzle is an oval shape. (See page 20 for more on muzzles.)

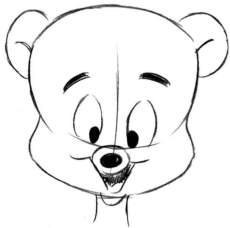

Once you've got the basic foundation firmly in place, you can start adding fun stuff, like the smile, the creases of the cheeks, the ears, and the neck. Note that baby animals either have no neck or a very thin one.

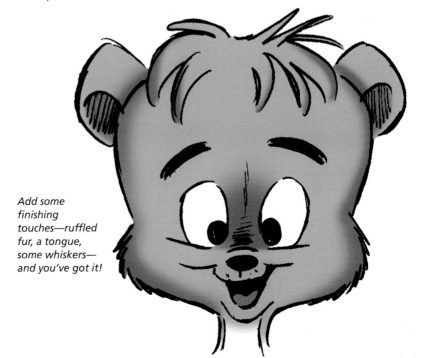

Add some finishing touches—ruffled fur, a tongue, some whiskers— and you've got it!

The Head in 3/4 View

Now try the baby animal head from a 3/4 view so that you can get comfortable drawing angles other than the front view. While you can apply these general steps to drawing any baby animal, note that bears have a different head structure from, say, a dog, on which the snout extends fluidly from the forehead. On the bear, the snout really juts out at a sharp angle to the plane of the face and almost gives the feeling of being stuck onto the head.

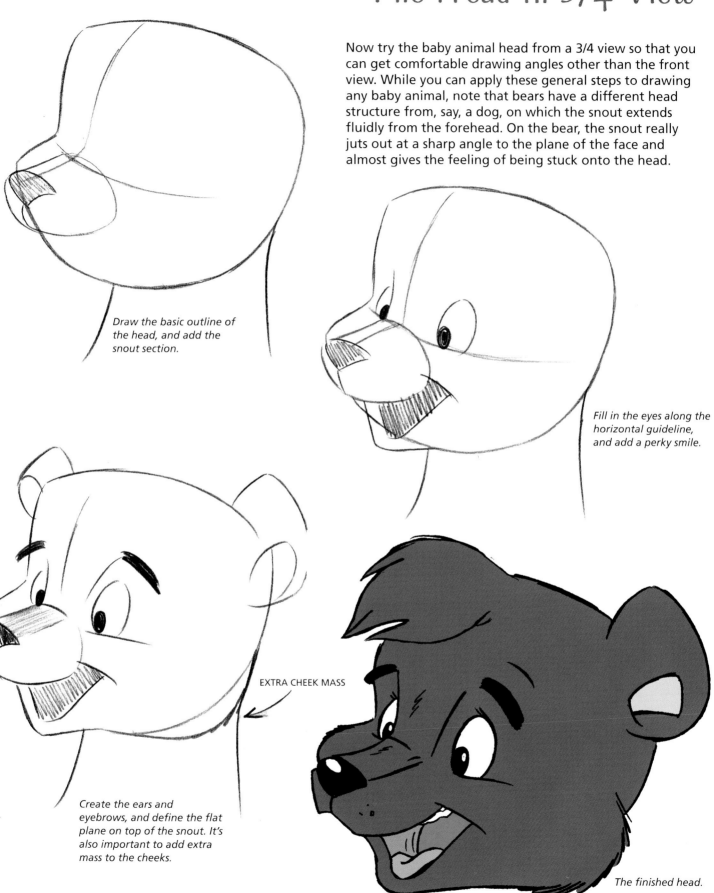

Draw the basic outline of the head, and add the snout section.

Fill in the eyes along the horizontal guideline, and add a perky smile.

EXTRA CHEEK MASS

Create the ears and eyebrows, and define the flat plane on top of the snout. It's also important to add extra mass to the cheeks.

The finished head.

The Baby Animal Body

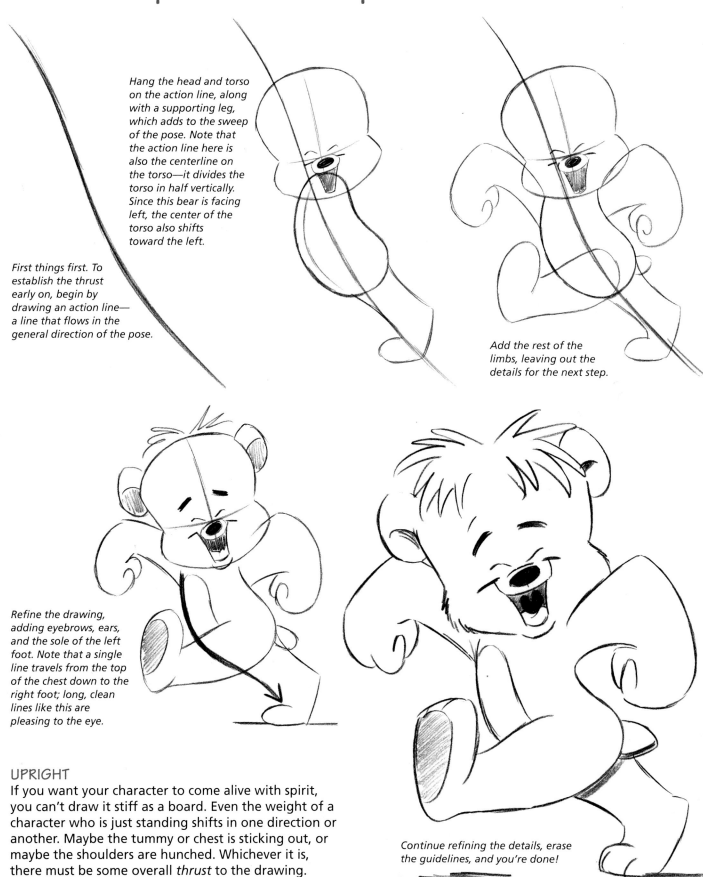

Hang the head and torso on the action line, along with a supporting leg, which adds to the sweep of the pose. Note that the action line here is also the centerline on the torso—it divides the torso in half vertically. Since this bear is facing left, the center of the torso also shifts toward the left.

First things first. To establish the thrust early on, begin by drawing an action line— a line that flows in the general direction of the pose.

Add the rest of the limbs, leaving out the details for the next step.

Refine the drawing, adding eyebrows, ears, and the sole of the left foot. Note that a single line travels from the top of the chest down to the right foot; long, clean lines like this are pleasing to the eye.

UPRIGHT

If you want your character to come alive with spirit, you can't draw it stiff as a board. Even the weight of a character who is just standing shifts in one direction or another. Maybe the tummy or chest is sticking out, or maybe the shoulders are hunched. Whichever it is, there must be some overall *thrust* to the drawing.

Continue refining the details, erase the guidelines, and you're done!

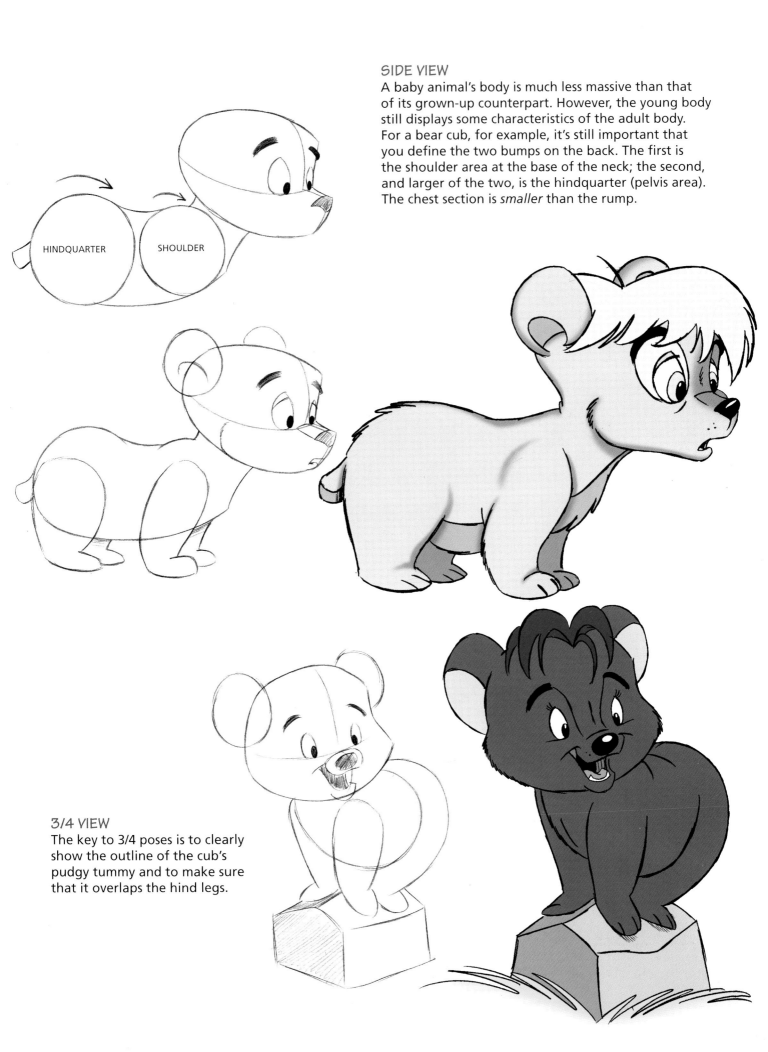

SIDE VIEW

A baby animal's body is much less massive than that of its grown-up counterpart. However, the young body still displays some characteristics of the adult body. For a bear cub, for example, it's still important that you define the two bumps on the back. The first is the shoulder area at the base of the neck; the second, and larger of the two, is the hindquarter (pelvis area). The chest section is *smaller* than the rump.

HINDQUARTER

SHOULDER

3/4 VIEW

The key to 3/4 poses is to clearly show the outline of the cub's pudgy tummy and to make sure that it overlaps the hind legs.

Animals That Walk Like People

Cartoonists love to give animals human characteristics. It makes the animals more childlike and charming. So, in addition to giving your characters bright eyes and youthful expressions, try drawing them upright on two legs—instead of walking on all fours.

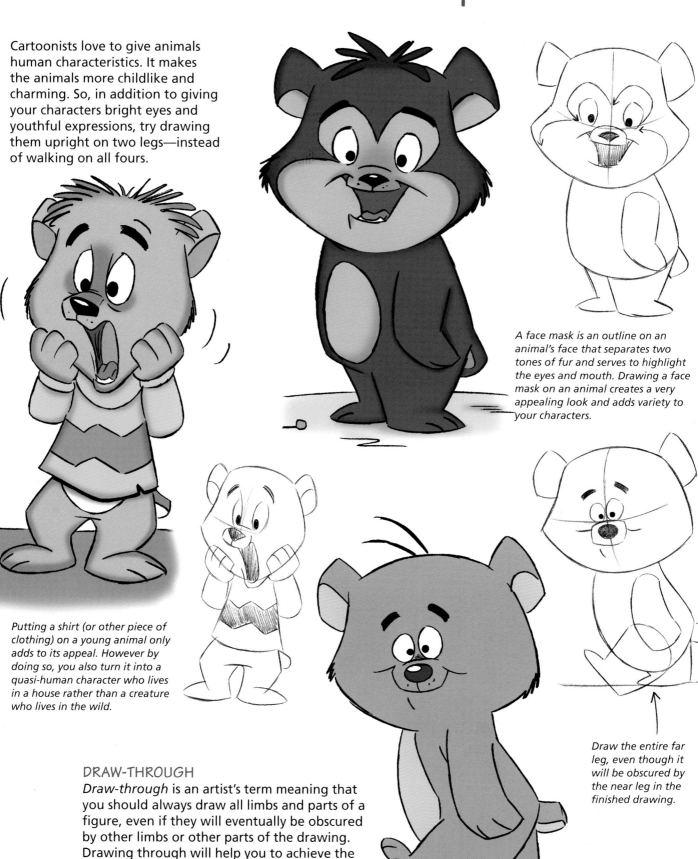

A face mask is an outline on an animal's face that separates two tones of fur and serves to highlight the eyes and mouth. Drawing a face mask on an animal creates a very appealing look and adds variety to your characters.

Putting a shirt (or other piece of clothing) on a young animal only adds to its appeal. However by doing so, you also turn it into a quasi-human character who lives in a house rather than a creature who lives in the wild.

DRAW-THROUGH

Draw-through is an artist's term meaning that you should always draw all limbs and parts of a figure, even if they will eventually be obscured by other limbs or other parts of the drawing. Drawing through will help you to achieve the correct positioning for your characters.

Draw the entire far leg, even though it will be obscured by the near leg in the finished drawing.

10

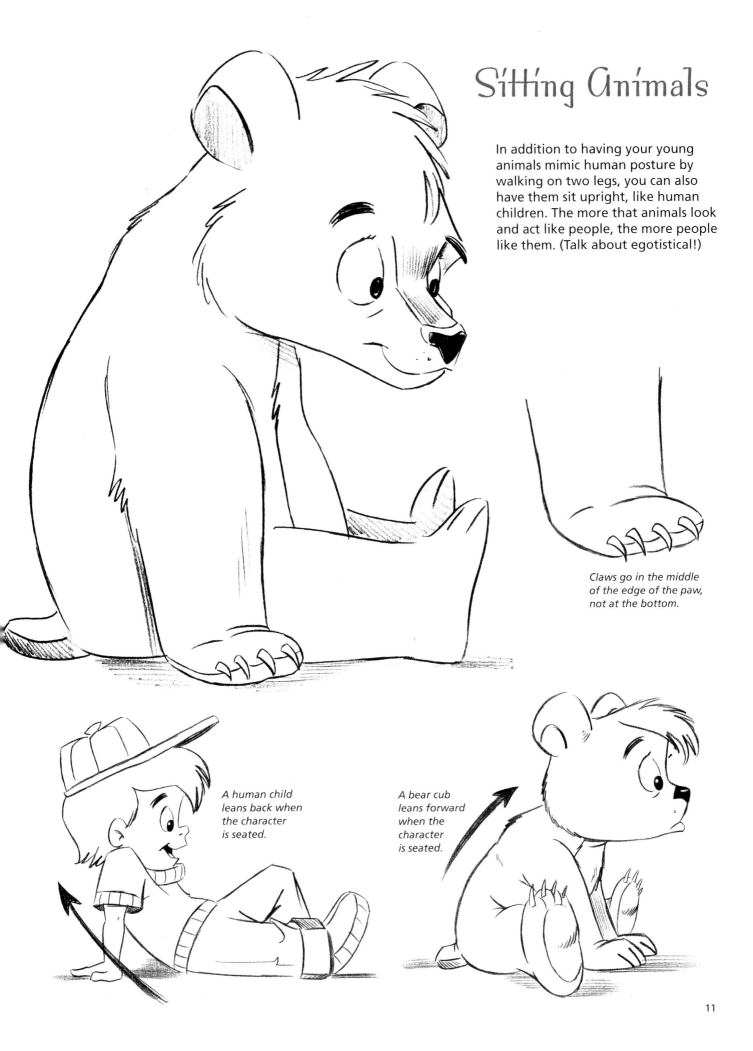

Sitting Animals

In addition to having your young animals mimic human posture by walking on two legs, you can also have them sit upright, like human children. The more that animals look and act like people, the more people like them. (Talk about egotistical!)

Claws go in the middle of the edge of the paw, not at the bottom.

A human child leans back when the character is seated.

A bear cub leans forward when the character is seated.

Simple Animal Anatomy

The underlying skeleton of every animal is a complex arrangement of bones. To make it easier to remember and draw, I've simplified the bone structure to a few basic elements. You'll be surprised how easy they are to remember and duplicate. It makes drawing easier and more fun.

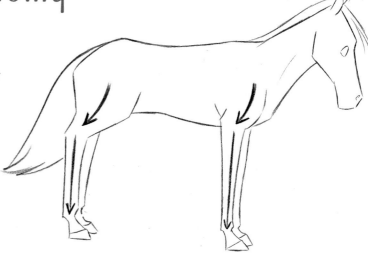

This basic structure works for a horse . . .

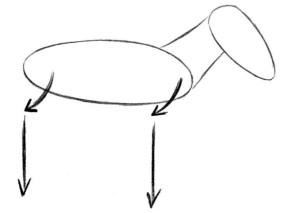

Here's a rough sketch of your basic four-legged animal. Note that the top of the limbs are short and curve backward (short arrows), while the bottom of the limbs are long and travel straight down (long arrows).

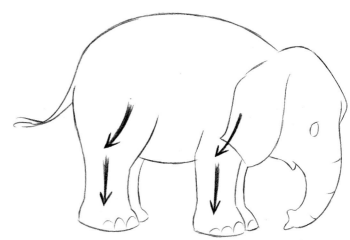

. . . as well as for an elephant . . .

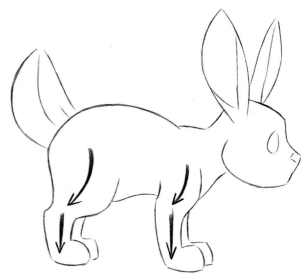

. . . as well as for a rabbit—and many other four-legged creatures.

Types of Baby Animal Characters

In the world of cartoons, comic strips, and animation, baby animals generally fall into one of five different personality groups, each with its own body type.

THE GIANT BABY
This is the bumbling, over-sized animal that doesn't know its own strength.

THE GOOFY BABY
This character's a cute little critter but still a bit on the dizzy side.

THE LEGGY, AWKWARD BABY
Usually, this is a baby animal with hooves (such as a horse or cow), whose limbs are quite long relative to the size of its body. These youngsters are a bit off balance on their new legs.

THE WARM AND FUZZY BABY
The cartoon equivalent of a plush doll—you just wanna sque-e-e-eze him!

THE EVIL, BRATTY, OR GENIUS BABY
This young animal makes a great character, because it goes *against type*, meaning that its personality is the opposite of what you would expect and assume it to be. These babies have big heads, short little bodies, and intense eyes.

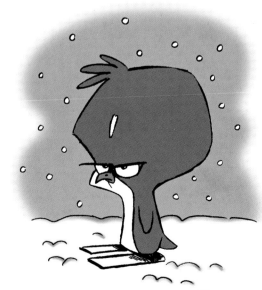

Baby vs. Adult Proportions

Here's where many beginners make a critical mistake. They believe that a baby or young animal is simply a smaller version of its parent. However, if you look closely at the horses on this page, you'll see that the adult is not just larger but more robust in stature. Its neck is thicker relative to its head. Its muscles are more substantial overall. The younger horse is bonier. Its hooves are bigger relative to its limbs. And, its mane is floppier.

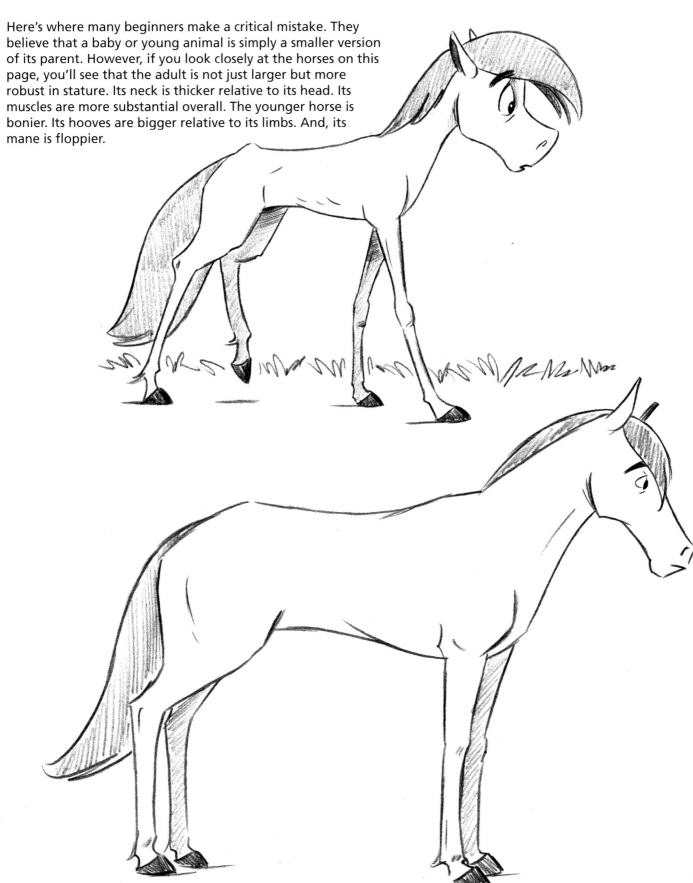

The Keys to Drawing a Young Animal

Every species has certain traits that are unique to it, and we'll get to those unique aspects later on as we cover each animal individually. But, it's always useful to have a general sense of things before getting too specific. These are some general points to watch for when drawing a baby animal.

CUB

There is hardly anything cuter than a fuzzy bear cub. Here are the characteristics that will help you capture that cute baby quality.

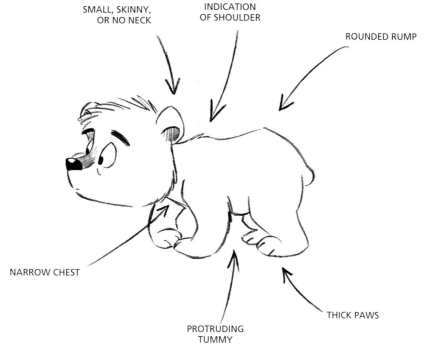

SMALL, SKINNY, OR NO NECK

SLIGHT OR NO INDICATION OF SHOULDER

ROUNDED RUMP

NARROW CHEST

PROTRUDING TUMMY

THICK PAWS

ADULT

Note the powerful neck, huge shoulder hump, and thin paws as compared to the cub. The posture is also different.

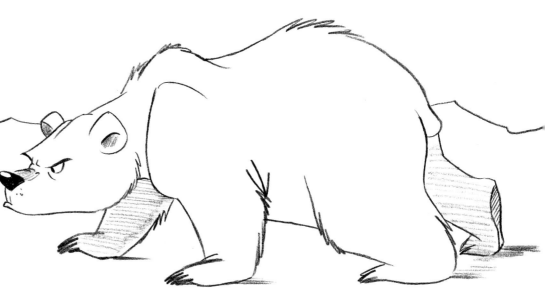

The Paws of Various Species

Drawings are made up of details; you can create a good overall drawing, but ruin it by fudging the parts you don't know. Usually for beginners, those parts are hands, or in this case, paws. Luckily, hind paws are basically identical to front paws, which makes things easier. Here are examples of some of the more popular species.

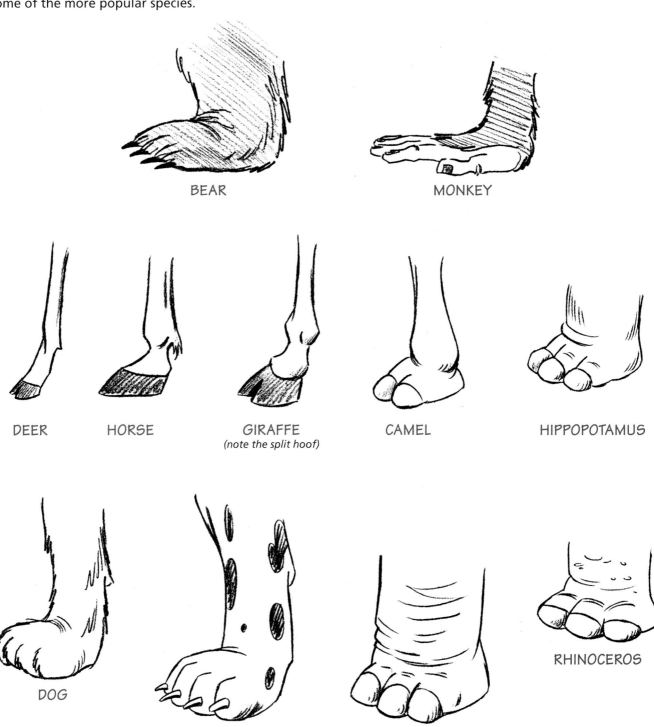

BEAR

MONKEY

DEER HORSE GIRAFFE
 (note the split hoof)

CAMEL HIPPOPOTAMUS

DOG

LEOPARD
(same for other big cats)

ELEPHANT

RHINOCEROS

Drawing the Eyes in Perspective

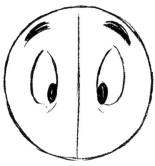

Both eyes are the same size in the front view.

In order to get the maximum cuteness out of your drawings, you must, MUST, MUST focus on the eyes. While some characters have eyes that are close together, the surest way to create an endearing, young character is to draw the eyes far apart from each other. This helps to emphasize the roundness of the forehead, and people have a subconscious positive emotional response to rounded objects.

However, spacing the eyes apart is only half the technique. You must also make the eyes bigger or smaller, depending on where they appear on the forehead. This is due to the principle of perspective, which tells us that objects closer to us appear larger than objects farther away from us. Notice how, on all but one of these heads, the near eye is bigger while the far eye is smaller and more slender. When looking straight ahead, the eyes are the same size because neither is further away from the viewer than the other.

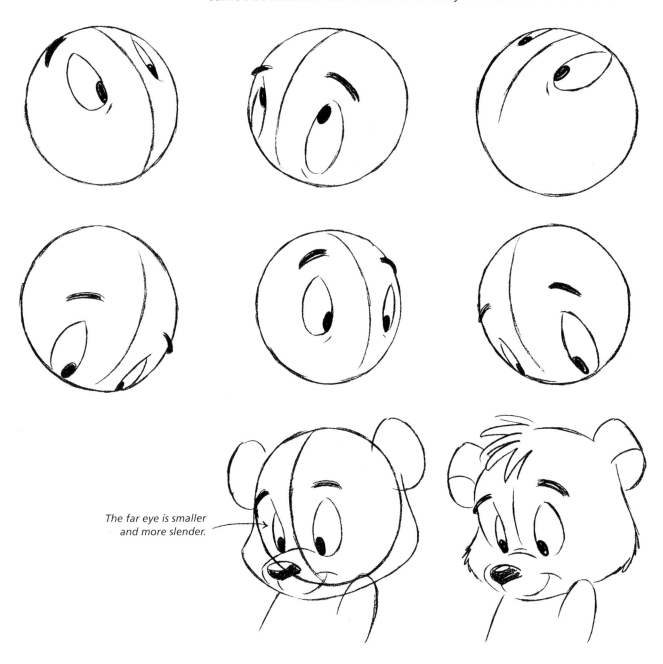

The far eye is smaller and more slender.

The Slope of the Forehead

If there's one secret to creating engaging, cute baby animals, this would have to be it: Round off the forehead so that it slides gently down the top of the nose. In fact, if you were to follow the curve of the forehead with an arrow, it should look like a slide. There should be no abrupt change of angle from forehead to nose, but rather, an easy, graceful curve.

Note the uninterrupted flow from the forehead to the top of the nose.

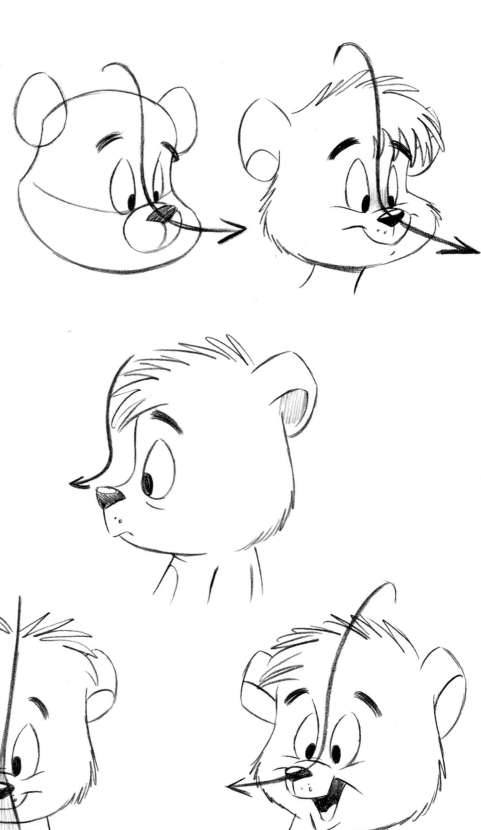

Here are a few more things to keep in mind when drawing the head and eyes of baby animals.

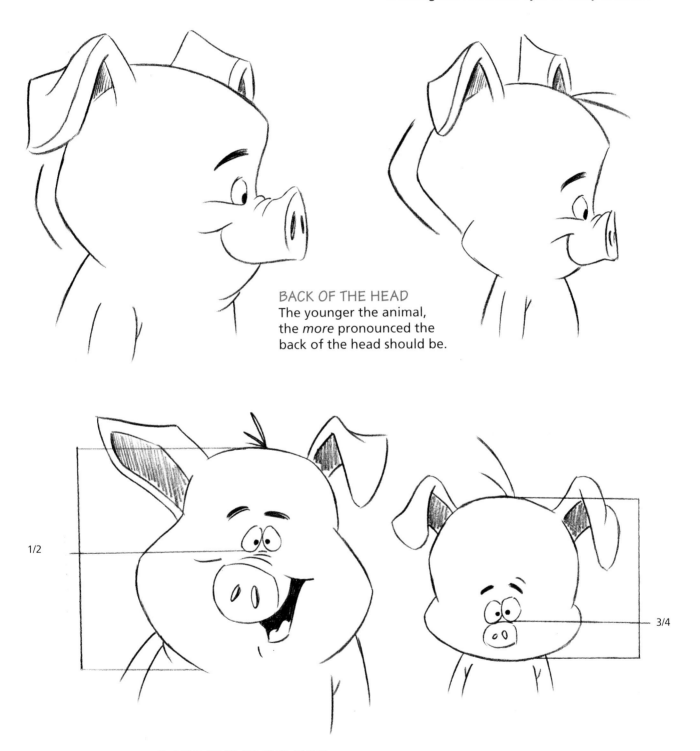

BACK OF THE HEAD
The younger the animal, the *more* pronounced the back of the head should be.

1/2

3/4

PLACEMENT OF THE EYES
The younger the animal, the *lower* the eyes should be on its head. Here, the pig's eyes are positioned halfway down the head, whereas the piglet's eyes are set about 3/4 of the way down the head.

Youthful Muzzles

The muzzle is not the nose. The nose is only the part that smells things. The muzzle, however, is the entire mouth, nose, and jaw area, which protrudes on most animals. It is the most important part of the face to reduce in creating a convincing baby animal. Long muzzles are for adults; short muzzles are for youngsters. Note, too, that the younger the animal, the smaller the chin. In many baby animals, you can eliminate the chin altogether.

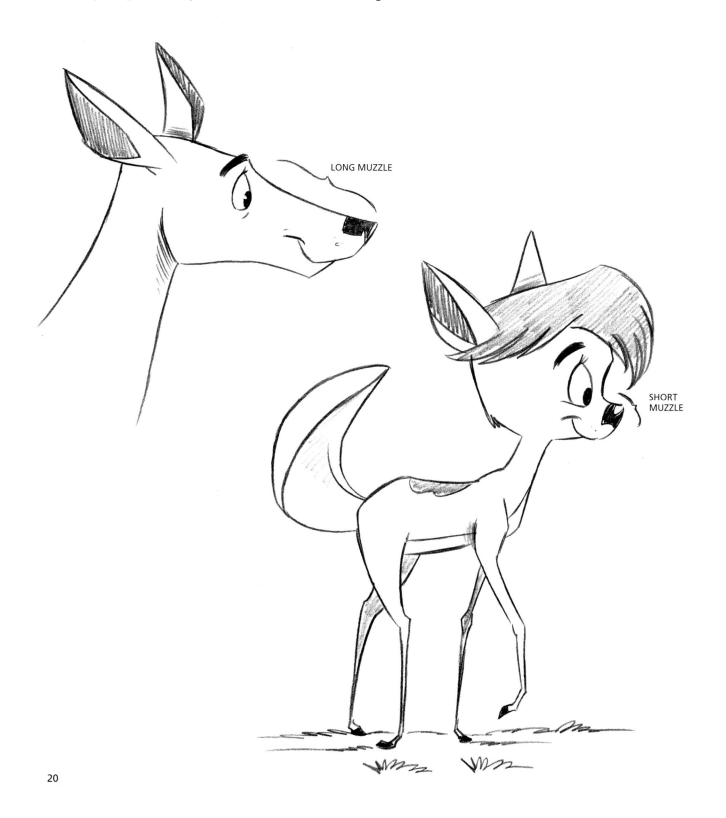

LONG MUZZLE

SHORT MUZZLE

WOLF CUB

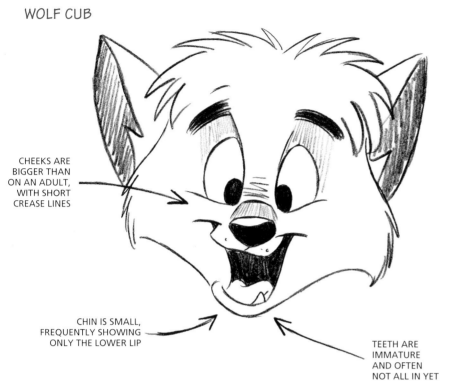

CHEEKS ARE BIGGER THAN ON AN ADULT, WITH SHORT CREASE LINES

CHIN IS SMALL, FREQUENTLY SHOWING ONLY THE LOWER LIP

TEETH ARE IMMATURE AND OFTEN NOT ALL IN YET

The mouth of a young animal should be rubbery—able to stretch in any direction and full of expression. In a smile, the mouth opens wide so that you can see inside it. It's also important to note that the upper lip section of the adult animal is always, always wider than it is on a younger animal.

In addition, the shape of the entire head changes in relation to the movements of the mouth. This is true for both adult and baby characters. For example, the head becomes long and thin (something animators refer to as *stretching*) if the mouth is clamped down shut with teeth gritted, or it becomes short and fat (something animators refer to as *squashing* or *bunching*) if the mouth is wide open in a smile.

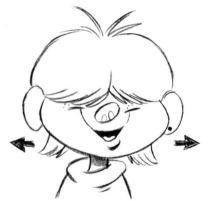

SQUASHING

WOLF

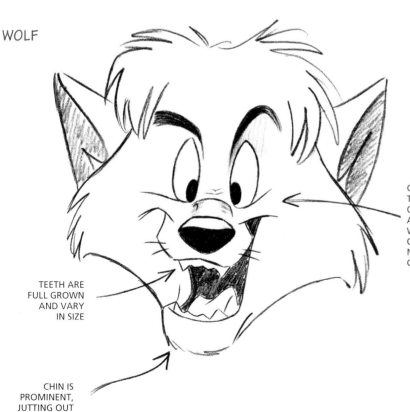

CHEEKS ARE THINNER THAN ON A YOUNGER ANIMAL, WITH LONGER OR MORE NUMEROUS CREASE LINES

TEETH ARE FULL GROWN AND VARY IN SIZE

CHIN IS PROMINENT, JUTTING OUT

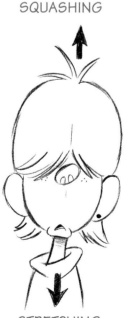

STRETCHING

Drawing the Ruffles of Fur

If you don't draw natural-looking fur ruffles, it doesn't matter how well you draw the rest of the animal—it still won't look cute. Creating the ruffles is a problem for many people, even those who've mastered most of the other aspects of drawing animal characters. But never fear. Here are the secrets to getting this easy, but little-understood, detail just right.

TOP OF HEAD

INNER EARS

CHEEKS

CHIN (EVEN A SMALL ONE)

TIP OF TAIL

CHEST

RUFFLES FOR DIFFERENT SPECIES
Each species is unique. You'll often have to place the fur ruffles on different areas of different animals. On certain animals, some ruffles are the identifying markings. So, be sure to treat the ruffles accordingly, depending on the particular species. Here are a few species-specific fur characteristics to note.

BEST PLACES FOR RUFFLES OF FUR
Here's your basic kitten with arrows indicating which areas should have ruffles. The rest of the body remains smooth. Most animals follows this example.

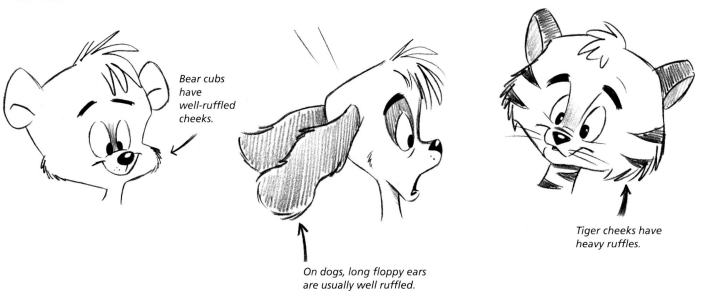

Bear cubs have well-ruffled cheeks.

On dogs, long floppy ears are usually well ruffled.

Tiger cheeks have heavy ruffles.

Ruffles on the Cheeks

How do you draw fur ruffles on the cheeks? Do they continue in a single line, feathering around the entire jaw? Or, do they meet in the middle at the chin? If you don't handle this detail well, the result will look quite awkward. Compare these examples.

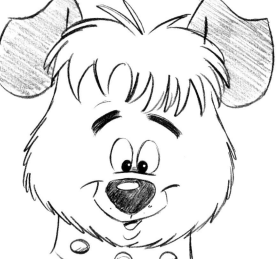

RUFFLES ALL THE WAY AROUND IN ONE DIRECTION

Not a good solution. This makes the animal look too furry, almost wild. Plus, the ruffles on one side of the cheek will look good, while the ruffles on the other side will look upside down.

RUFFLES MEETING IN THE MIDDLE

As with the example at left, these ruffles give the feeling that there's too much fur. Plus, the sharp change in direction of the ruffles under the chin is jarring to the eyes.

RUFFLES ON EACH CHEEK

These cheek ruffles—with a large neutral space between them where they meet under the chin—are the most natural looking. The straight line of neutral space serves as good "pacing" between the ruffles: It's a place where the eye can "rest."

Baby Animal Expressions

When creating expressions, make sure you draw your character from different angles, as well as tilt its head slightly up or down, or to one side or the other. This will give your drawings that extra touch that fills them with spirit.

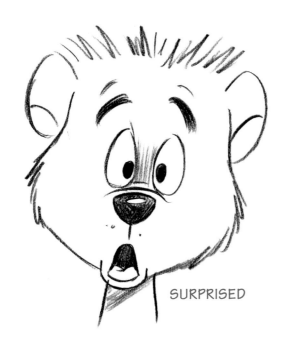

SURPRISED

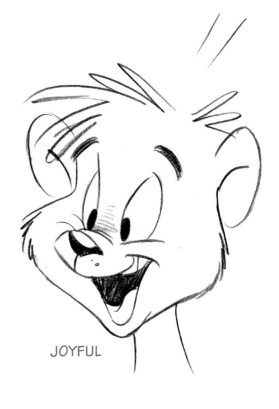

JOYFUL

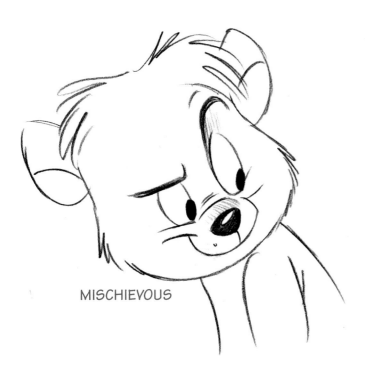

MISCHIEVOUS

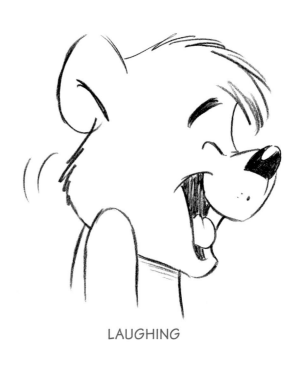

LAUGHING

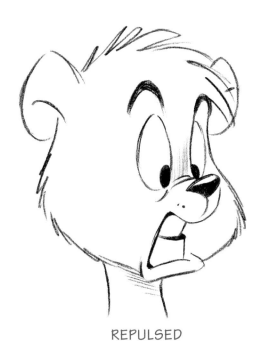

REPULSED

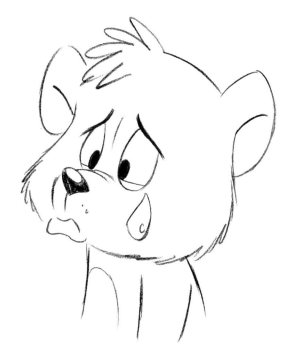

SAD

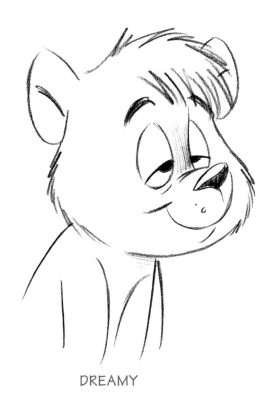

DREAMY

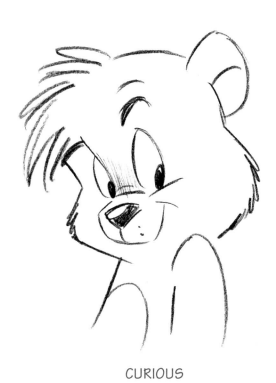

CURIOUS

WILD THINGS!

Elephants, monkeys, lions, tigers, hippos, and more! There's a marvelous supply of cute, cuddly animal toddlers in even the most dangerous spots on earth.

Elephants

With their big heads and compact little bodies, baby elephants are a sure winner in any story. Elephants have quite a limited range of motion. They have no necks and must, therefore, turn their entire bodies around in order to look in another direction. They cannot run, but merely walk very fast in what looks like a weird trot. Only the trunk of the elephant has a wide range of motion. It's not only flexible, but downright agile. Of course, elephants can flap their ears and tail at will, but these parts are not nearly as precise in movement as the trunk.

Elephant Legs

Long limbs on elephants? You betcha! Since elephants have gigantic girth, people wrongly assume that they must have short legs. However, the opposite is true. Elephants are actually long-limbed creatures, and this is true whether the animal is a youngster or an adult. Still, cartoons are based on stereotypes, and there's nothing wrong with creating an elephant that has short legs if that's what your character calls for. Compare these two approaches.

The legs are long in comparison to the body.

This is a very exaggerated version of a short-legged baby elephant. Although not possible in reality, in cartoons an elephant with short legs works equally well as one with long legs.

Elephant Details

HAIR

Hair? On an elephant? Yep, and here's why: Hey, it's a cartoon! You can do anything you like if it looks good and there's a reason for it. And, the reason here is that more hair makes a character seem younger—this goes for people as well as animals. The extra-bushy head of hair here makes this little guy look like a tyke, perhaps even a mastodon tyke. It also serves to create a more unique character that stands out from the other elephants. Note that if you draw tusks on a youngster, be sure they're small and immature, not the weapons they'll become when the elephant is an adult.

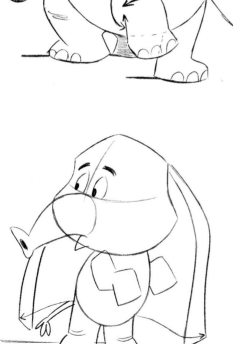

HUGE EARS

It's cute to draw a "cape" of ears that hangs behind the elephant. If you do this, draw the bottom of both ears as one single line, which is pleasing to the eye.

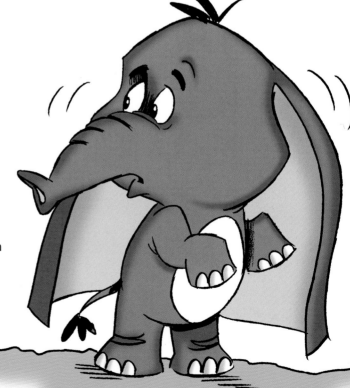

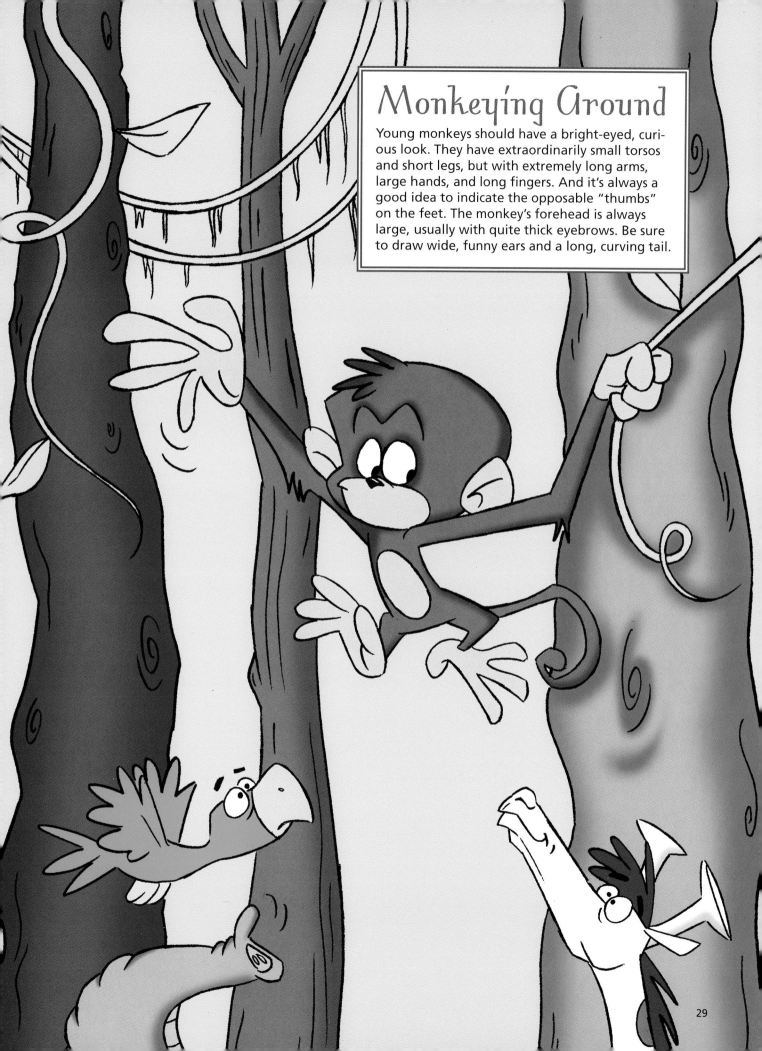

Monkeying Around

Young monkeys should have a bright-eyed, curious look. They have extraordinarily small torsos and short legs, but with extremely long arms, large hands, and long fingers. And it's always a good idea to indicate the opposable "thumbs" on the feet. The monkey's forehead is always large, usually with quite thick eyebrows. Be sure to draw wide, funny ears and a long, curving tail.

Primate Primer

Although primates have a lot in common, the monkey is *not* all that similar to the powerful gorilla —and neither is the baby monkey all that similar to the baby gorilla. The gorilla gets its fearsome look from its wide neck and shoulders. The monkey, in contrast, should have small shoulders and a skinny neck (or no neck), as do the baby monkeys on this page.

TYPICAL MONKEY STANCE
Monkeys rest on the backs of their hands, not on the palms. Note the opposable "thumbs" indicated on the feet.

Note the use of a single line to create both eyebrows.

Keep the chin small and the space between the monkey's nose and upper lip long.

Gangly arms are the key to the monkey body.

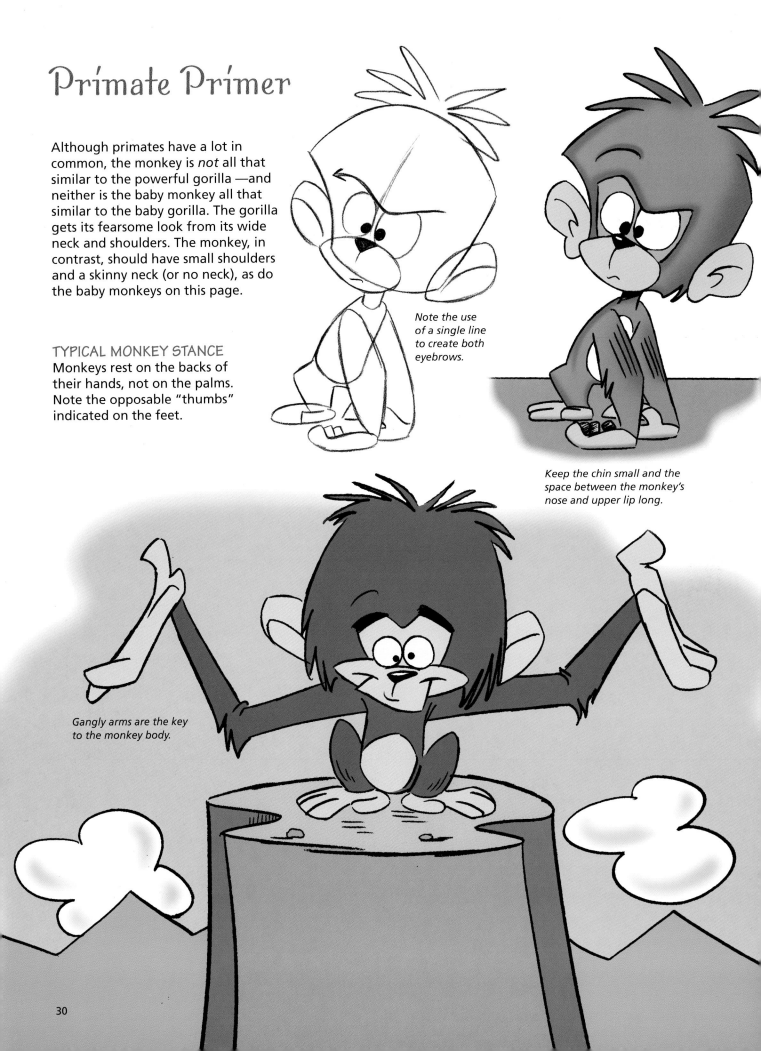

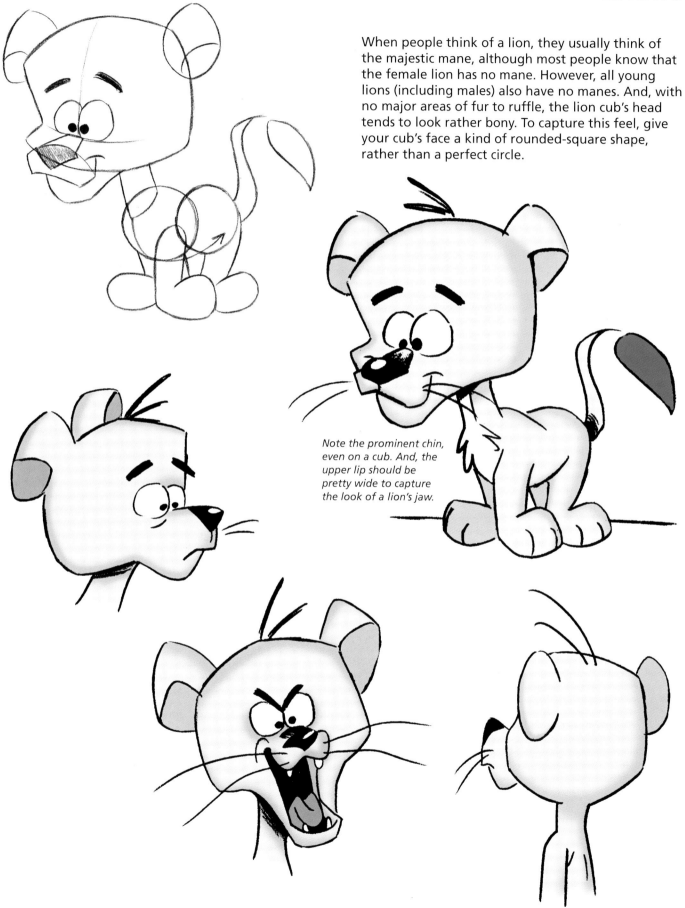

When people think of a lion, they usually think of the majestic mane, although most people know that the female lion has no mane. However, all young lions (including males) also have no manes. And, with no major areas of fur to ruffle, the lion cub's head tends to look rather bony. To capture this feel, give your cub's face a kind of rounded-square shape, rather than a perfect circle.

Note the prominent chin, even on a cub. And, the upper lip should be pretty wide to capture the look of a lion's jaw.

Tigers

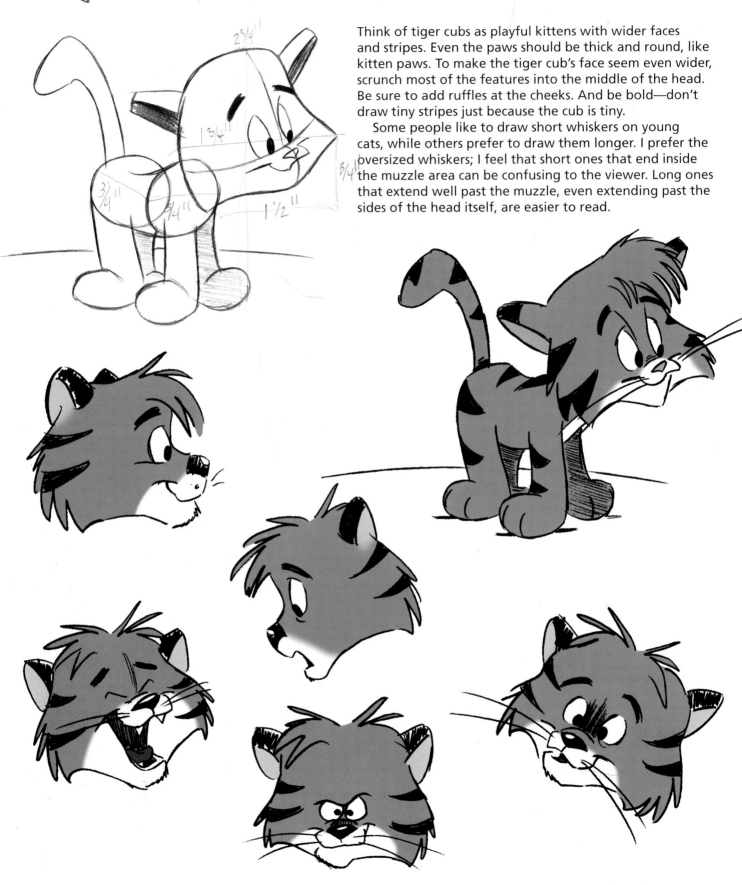

Think of tiger cubs as playful kittens with wider faces and stripes. Even the paws should be thick and round, like kitten paws. To make the tiger cub's face seem even wider, scrunch most of the features into the middle of the head. Be sure to add ruffles at the cheeks. And be bold—don't draw tiny stripes just because the cub is tiny.

Some people like to draw short whiskers on young cats, while others prefer to draw them longer. I prefer the oversized whiskers; I feel that short ones that end inside the muzzle area can be confusing to the viewer. Long ones that extend well past the muzzle, even extending past the sides of the head itself, are easier to read.

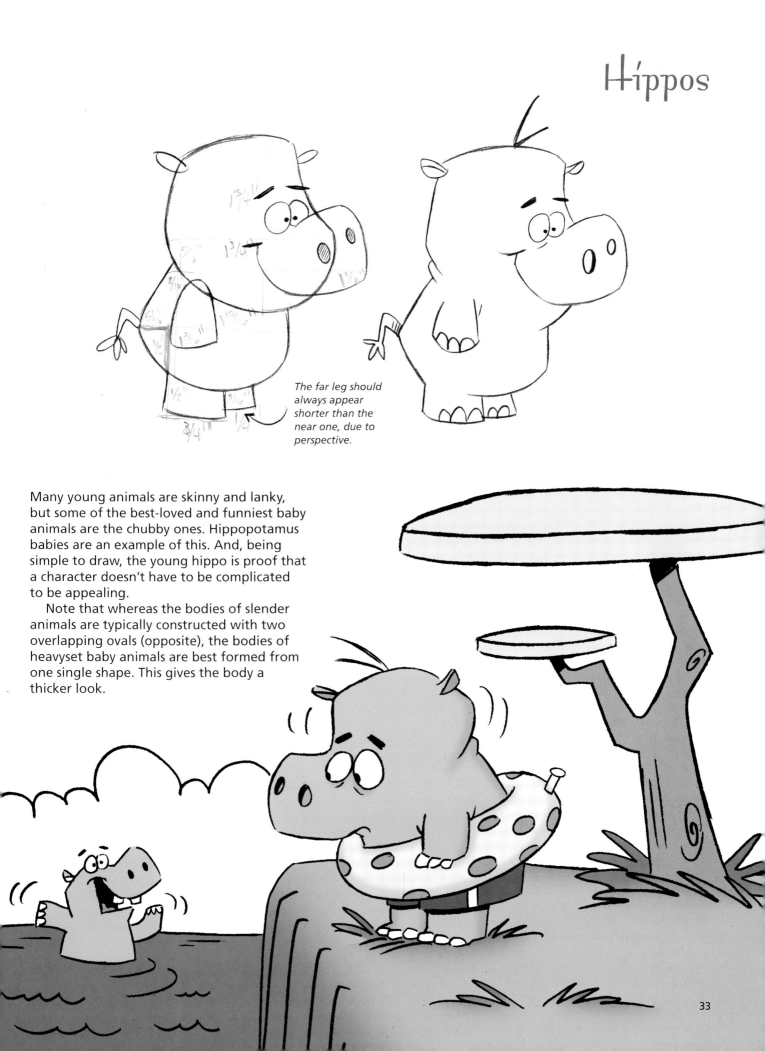

The far leg should always appear shorter than the near one, due to perspective.

Many young animals are skinny and lanky, but some of the best-loved and funniest baby animals are the chubby ones. Hippopotamus babies are an example of this. And, being simple to draw, the young hippo is proof that a character doesn't have to be complicated to be appealing.

Note that whereas the bodies of slender animals are typically constructed with two overlapping ovals (opposite), the bodies of heavyset baby animals are best formed from one single shape. This gives the body a thicker look.

Rhínos

There are two types of rhinoceros: African and Asian. The Asian rhino looks like it's wearing "armor plates," while the African rhino has smoother skin. The Asian rhino has only one horn, while the African rhino has two. Since a baby rhino's horn is small to begin with, adding a second, even smaller horn would be confusing to the viewer; therefore, it's best to draw only one horn no matter what species of rhino you choose to depict.

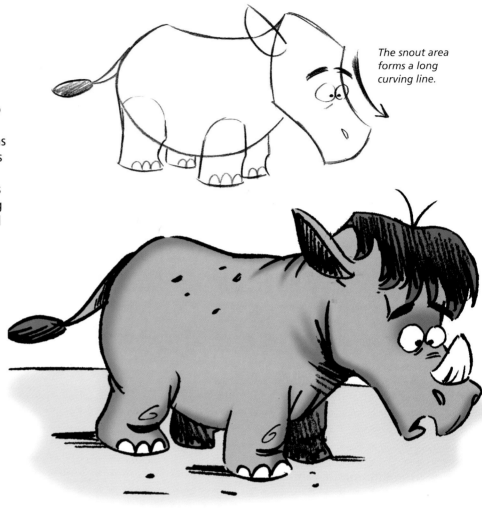

The snout area forms a long curving line.

Note that a rhino's upper lip hangs over its bottom one.

THE RHINOCEROS HEAD
The rhino's face is extremely long and narrow, but you can shorten and widen it, using a cartoony style as I've done with these infatuated rhinos.

CHARGE!

To indicate the "armor plates" of the Asian rhino, divide the body into thirds, as on this charging rhino.

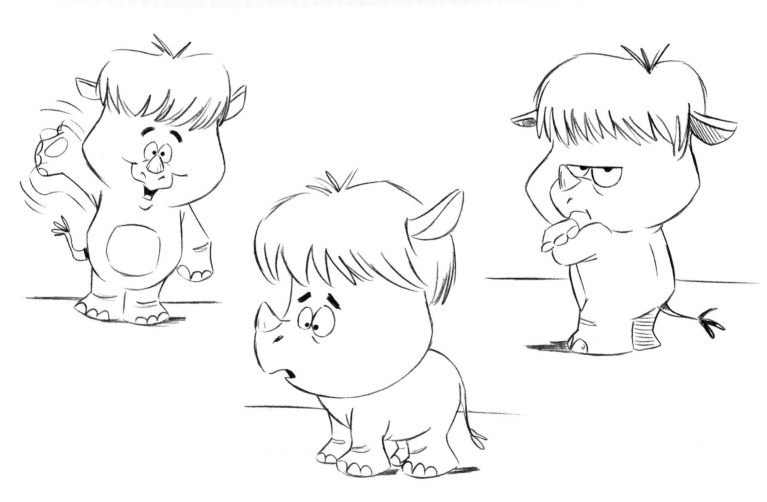

Giraffes

Giraffes have very strange bodies. Aside from the extremely long neck, the torso is compact and angular, with a noticeable hump at the shoulders.

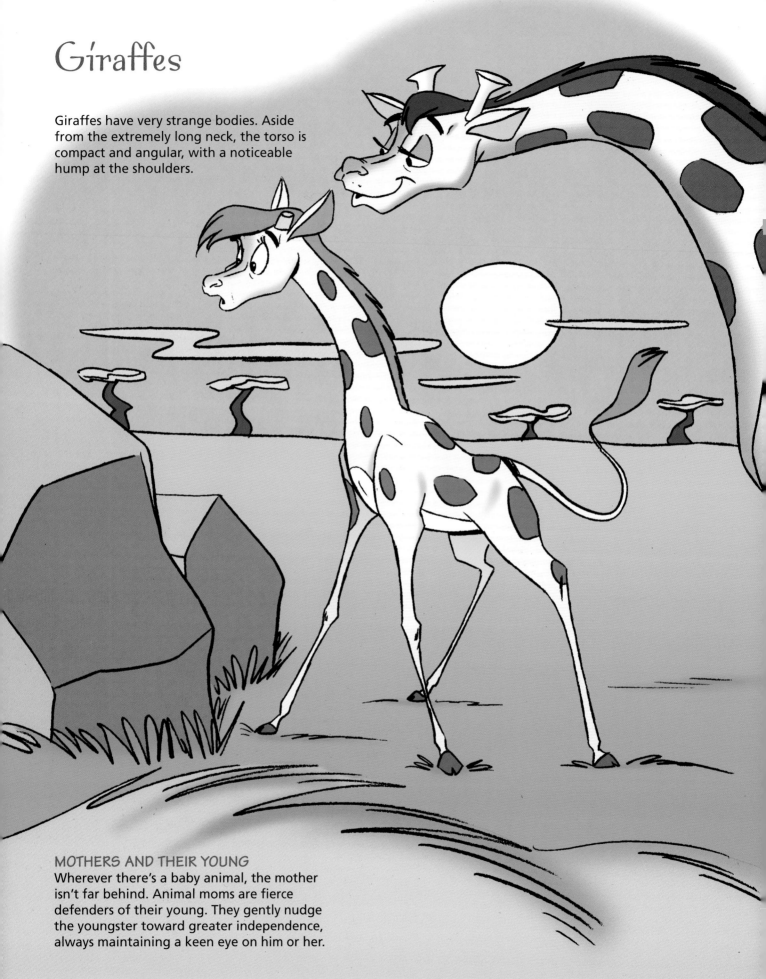

MOTHERS AND THEIR YOUNG
Wherever there's a baby animal, the mother isn't far behind. Animal moms are fierce defenders of their young. They gently nudge the youngster toward greater independence, always maintaining a keen eye on him or her.

Zebras

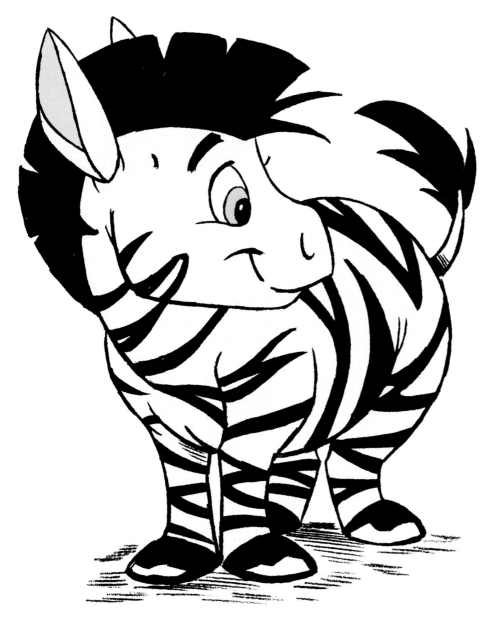

Yep, they're striped horses, but not exactly. You see the zebra head is shorter and wider than that of the horse. Plus, the mane sticks up like a mohawk. And, instead of a long flowing tail, formed completely of hair, the zebra tail starts out like a skinny stick, with loose hair at the end. Overall, the zebra body is more compact than a horse. But, even if you forget all this stuff, be sure to draw the stripes in the correct direction. They travel the short way around the body, not the long way, as in the diagram below.

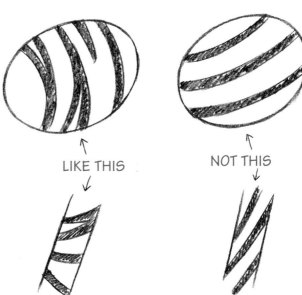

LIKE THIS NOT THIS

Bears

Bear cubs are some of my favorites. While adult bears can be quite intimidating and even menacing, baby bears are totally disarming. They should have lots of curves and be round and chubby, with fat cheeks, big paws, and cute protruding tummies. A little tuft of hair at the top of the forehead identifies the character as a youngster. Also, the snout on a cub is quite short, while the snout on an adult bear is long and rather pointy.

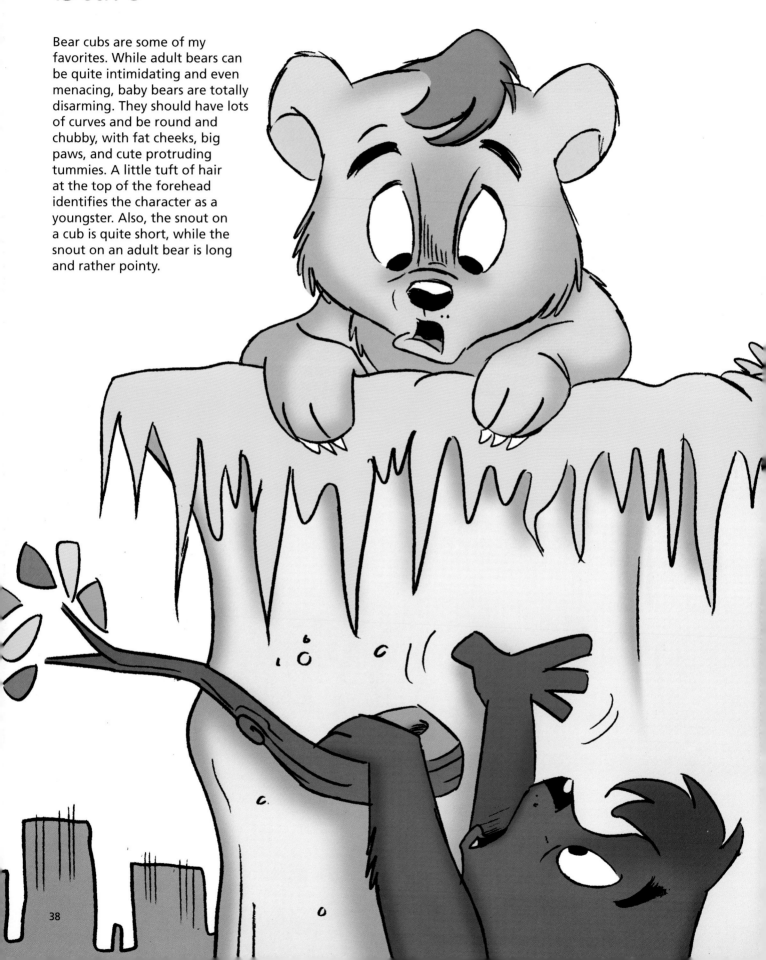

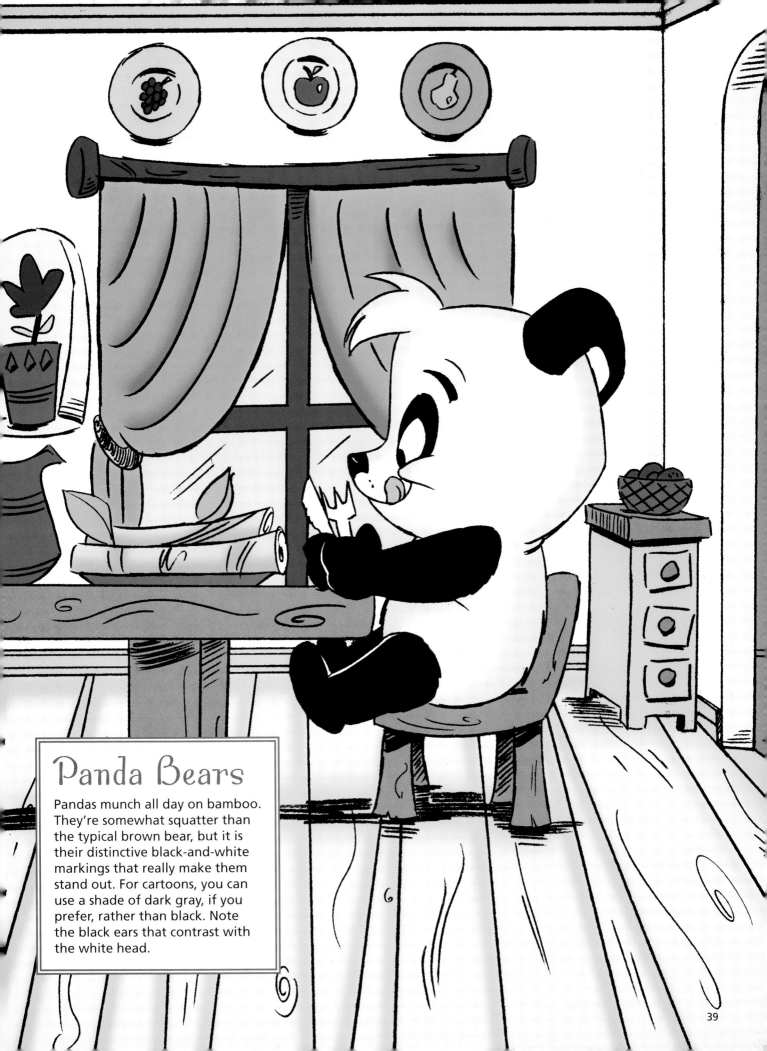

Panda Bears

Pandas munch all day on bamboo. They're somewhat squatter than the typical brown bear, but it is their distinctive black-and-white markings that really make them stand out. For cartoons, you can use a shade of dark gray, if you prefer, rather than black. Note the black ears that contrast with the white head.

SEA CREATURES AND REPTILES

People often have a fascination with the odd variety of things that live under the sea. This chapter provides some examples of popular baby sea creatures that you can add to your repertoire.

Underwater Youngsters

These animals spend their entire lives underwater.

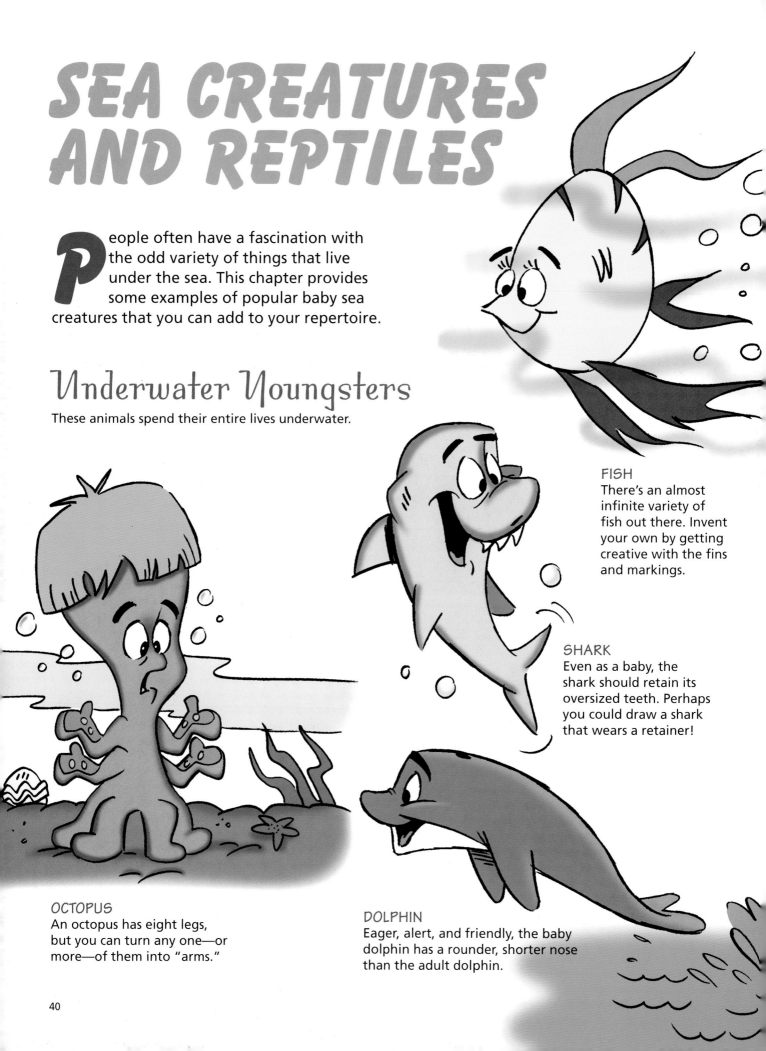

FISH
There's an almost infinite variety of fish out there. Invent your own by getting creative with the fins and markings.

SHARK
Even as a baby, the shark should retain its oversized teeth. Perhaps you could draw a shark that wears a retainer!

OCTOPUS
An octopus has eight legs, but you can turn any one—or more—of them into "arms."

DOLPHIN
Eager, alert, and friendly, the baby dolphin has a rounder, shorter nose than the adult dolphin.

Seals and Walruses

When I was a kid, my favorite animals to visit at the zoo were the seals. They're playful and have a great sense of fun. Here's a good tip for drawing successful seal pups. Take a look at the head of a seal. Does it remind you of anything? Imagine long, floppy ears hanging from its head. If you thought of a dog, you're right. The shape of a seal's head is very similar to that of a puppy, but without the long ears—and with extra whiskers.

The walrus pup, on the other hand, is a much plumper fellow, with a rounder head. Adult walruses are famous for their long tusks, but immature walruses, like the one here, don't have full-grown tusks yet. I like to space the baby tusks apart to make them look like buck teeth.

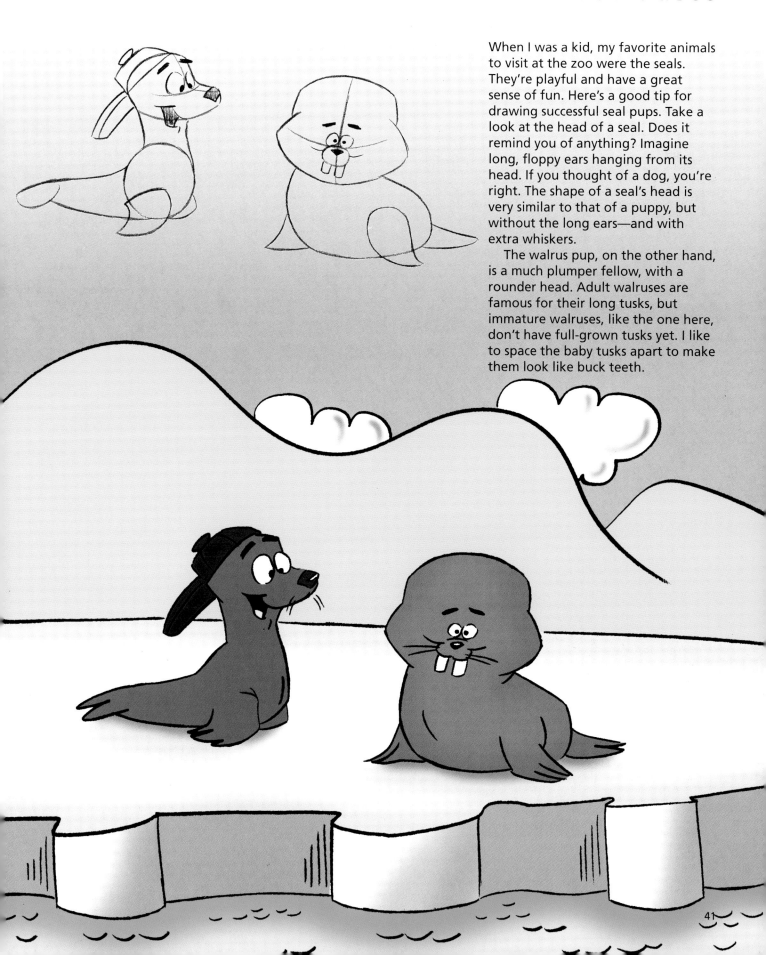

A Whale of a Baby

Even the biggest creatures on earth start out small—if you can call something the size of a sports utility vehicle small! To create a baby whale, keep the head large, but shorten the length of the body considerably. The head should be very wide. And, in order to add charm, it's important to increase the size of the eyes, which in reality are extremely small compared to the body.

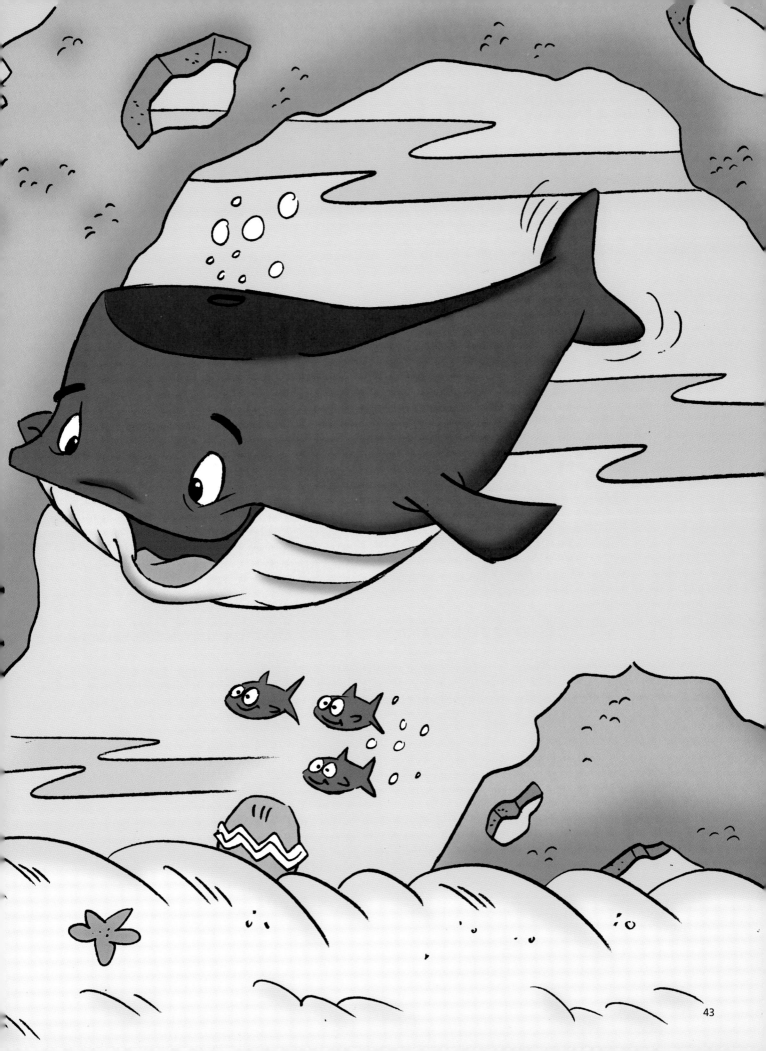

Alligators

Alligators are similar to crocodiles, but with one important difference: Alligators have wide noses while crocodiles have narrow ones, which makes the crocodiles look more sinister. You can exaggerate the wide nose of the baby alligator to make your character look goofy and cute. Also, placing the eyes close together creates a more attractive look.

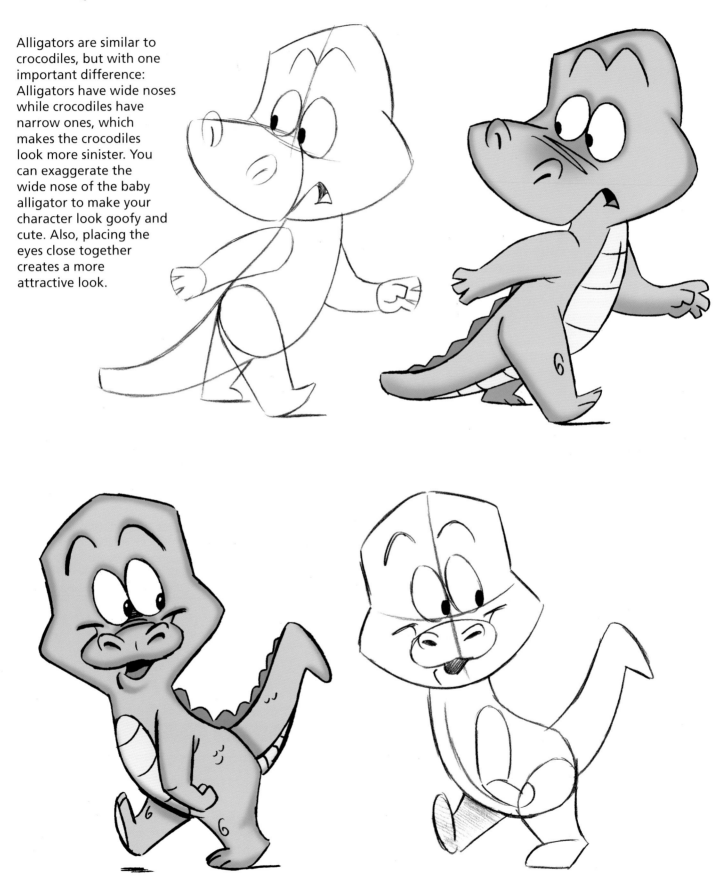

Turtles, Snakes, and Frogs

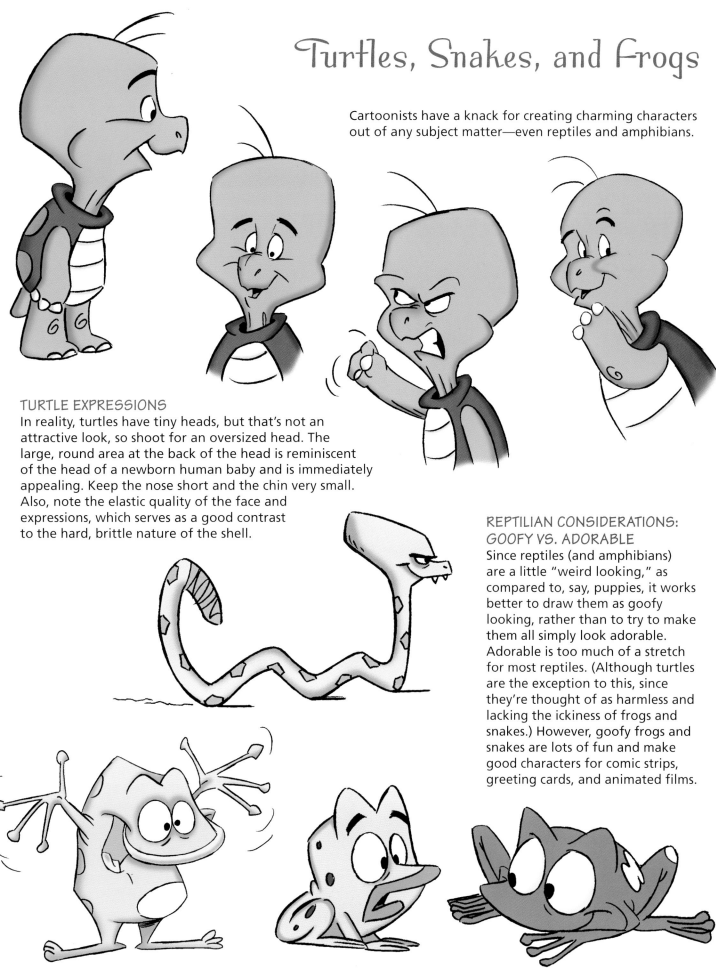

Cartoonists have a knack for creating charming characters out of any subject matter—even reptiles and amphibians.

TURTLE EXPRESSIONS

In reality, turtles have tiny heads, but that's not an attractive look, so shoot for an oversized head. The large, round area at the back of the head is reminiscent of the head of a newborn human baby and is immediately appealing. Keep the nose short and the chin very small. Also, note the elastic quality of the face and expressions, which serves as a good contrast to the hard, brittle nature of the shell.

REPTILIAN CONSIDERATIONS: GOOFY VS. ADORABLE

Since reptiles (and amphibians) are a little "weird looking," as compared to, say, puppies, it works better to draw them as goofy looking, rather than to try to make them all simply look adorable. Adorable is too much of a stretch for most reptiles. (Although turtles are the exception to this, since they're thought of as harmless and lacking the ickiness of frogs and snakes.) However, goofy frogs and snakes are lots of fun and make good characters for comic strips, greeting cards, and animated films.

SMALL CRITTERS

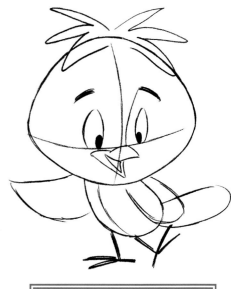

Not only the big guys are interesting. Here you'll find a few small rascals to add to your repertoire.

Basic Little Birds

You see these guys fluttering around the trees in your front lawn. Little birds—from blue jays to robins to sparrows—should have large heads and small bodies. Make the legs petite, and by contrast, draw the eyes quite large. Note that the wings can stretch out to function as arms with "fingers."

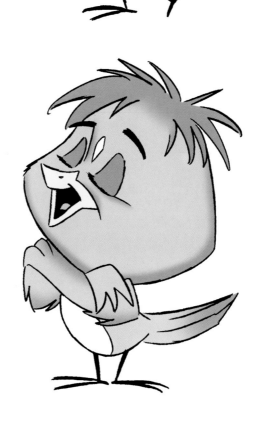

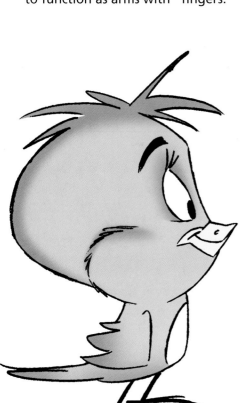

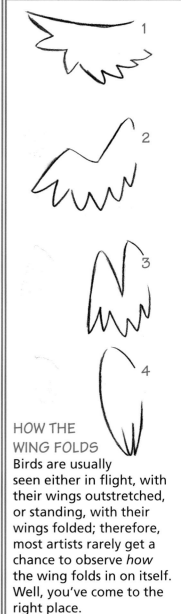

HOW THE WING FOLDS

Birds are usually seen either in flight, with their wings outstretched, or standing, with their wings folded; therefore, most artists rarely get a chance to observe *how* the wing folds in on itself. Well, you've come to the right place.

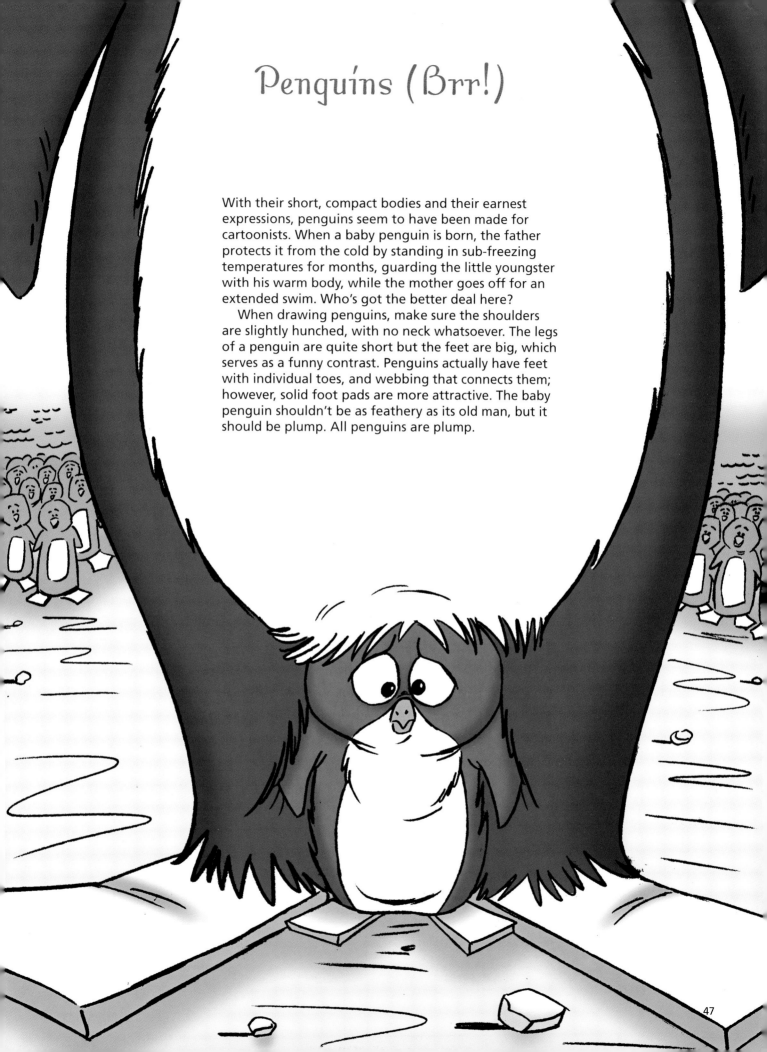

Penguins (Brr!)

With their short, compact bodies and their earnest expressions, penguins seem to have been made for cartoonists. When a baby penguin is born, the father protects it from the cold by standing in sub-freezing temperatures for months, guarding the little youngster with his warm body, while the mother goes off for an extended swim. Who's got the better deal here?

When drawing penguins, make sure the shoulders are slightly hunched, with no neck whatsoever. The legs of a penguin are quite short but the feet are big, which serves as a funny contrast. Penguins actually have feet with individual toes, and webbing that connects them; however, solid foot pads are more attractive. The baby penguin shouldn't be as feathery as its old man, but it should be plump. All penguins are plump.

Ducks

As you can see, the adult cartoon duck looks quite different from the cartoon duckling. While the adult is graceful and long necked, the baby waddles along with a huge head that teeters on a small body. Rounded feathers on the tips of the wings and tail are a good look for young birds. And, the immature beak is also shorter and rounder than the sleeker adult beak. Also note the long eyelashes on the duckling, which are an additional indication of youth.

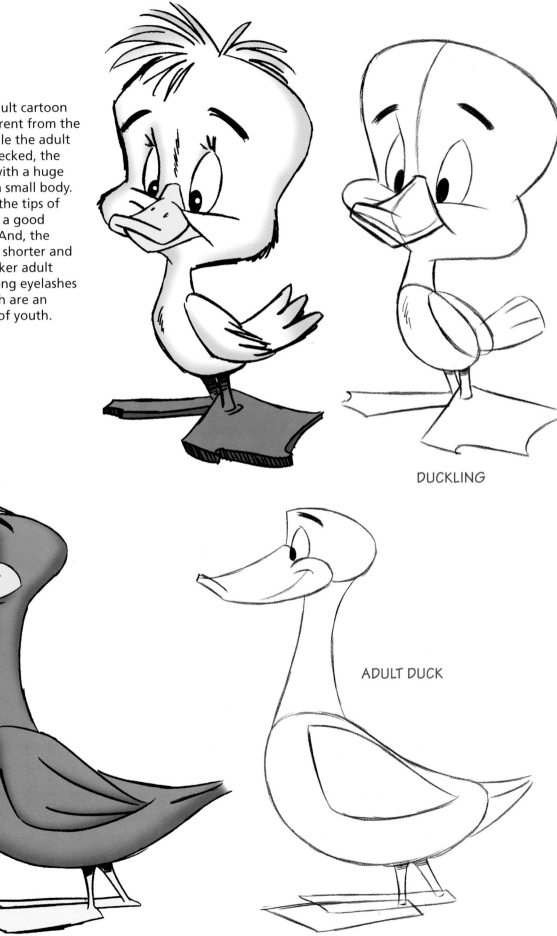

DUCKLING

ADULT DUCK

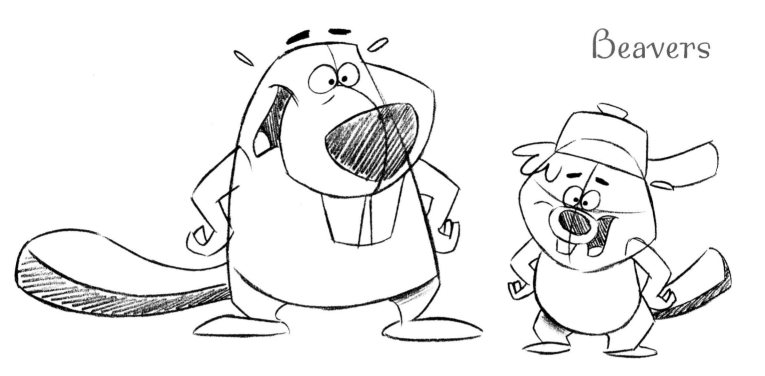

Timid little woodland animals have starred in many classic animated films and television shows, in addition to popping up in comic strips and even in spot gags in sophisticated magazines. With their enthusiastic can-do spirit—or as we'd put it today, their "obsessive-compulsive" personalities—they are a riot to watch. This father and son pair of beavers are about to eagerly take on a task. And no doubt, it will be exhausting to watch them! Note that the father has two huge teeth, but the son has only one. Also, the younger beaver has a larger forehead and more hair than the adult.

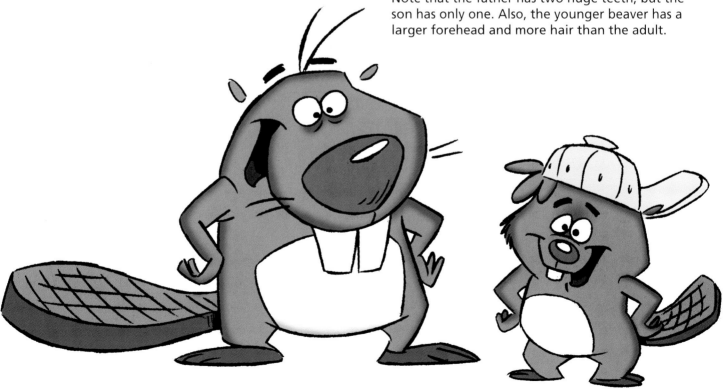

Pig-out!

The prominent features of the pig are its short, but large, snout and its corkscrew tail. However, there's another characteristic of the pig that's often overlooked: its large ears. These traits are found on piglets, as well. Of course, don't forget about the overall roundness of the pig. And, it's important to omit the neck and just attach the head directly to the shoulders.

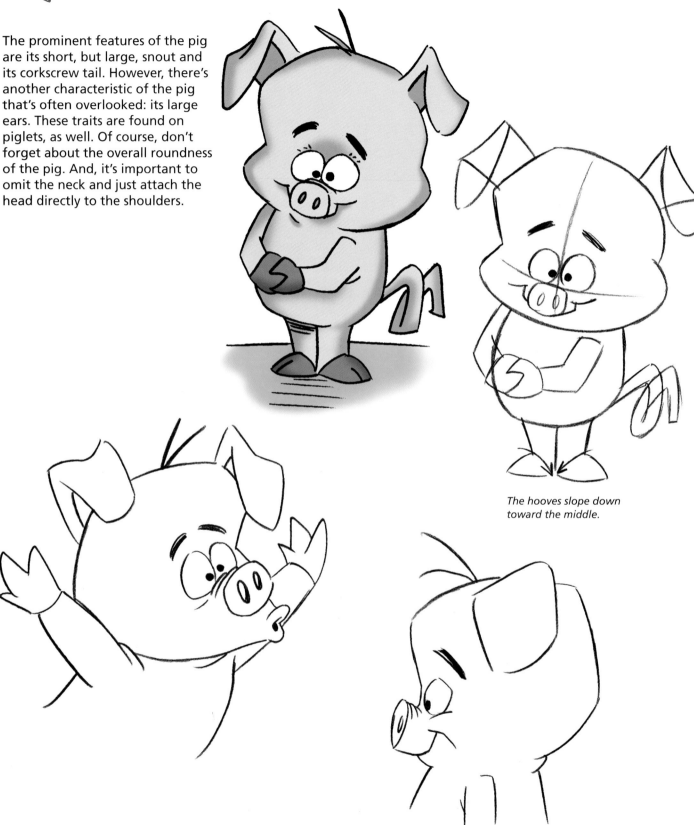

The hooves slope down toward the middle.

HUNGRY PIG
Hey, he didn't get that way by eating salad.

HOUSE PETS AND PESTS

What's the difference between a pet and a pest? If your mom shrieks when she sees one in the house, it's a pest.

Bunnies

You can caricature rabbits in many different ways, from crabby to cute to precocious. Here are a few examples.

CUTE 'N' FLUFFY
This bunny's head has two distinct parts: the forehead section and the mouth section. The ears are short and wide, and the interior area is defined. The paws are also softer, plumper, and rounder than they are on the grumpy rabbit.

GRUMPY
Even the long whiskers on this bunny seem to be in a bad mood! Note that the head has one overall shape. Also, it's not always necessary to indicate the interior of the ears.

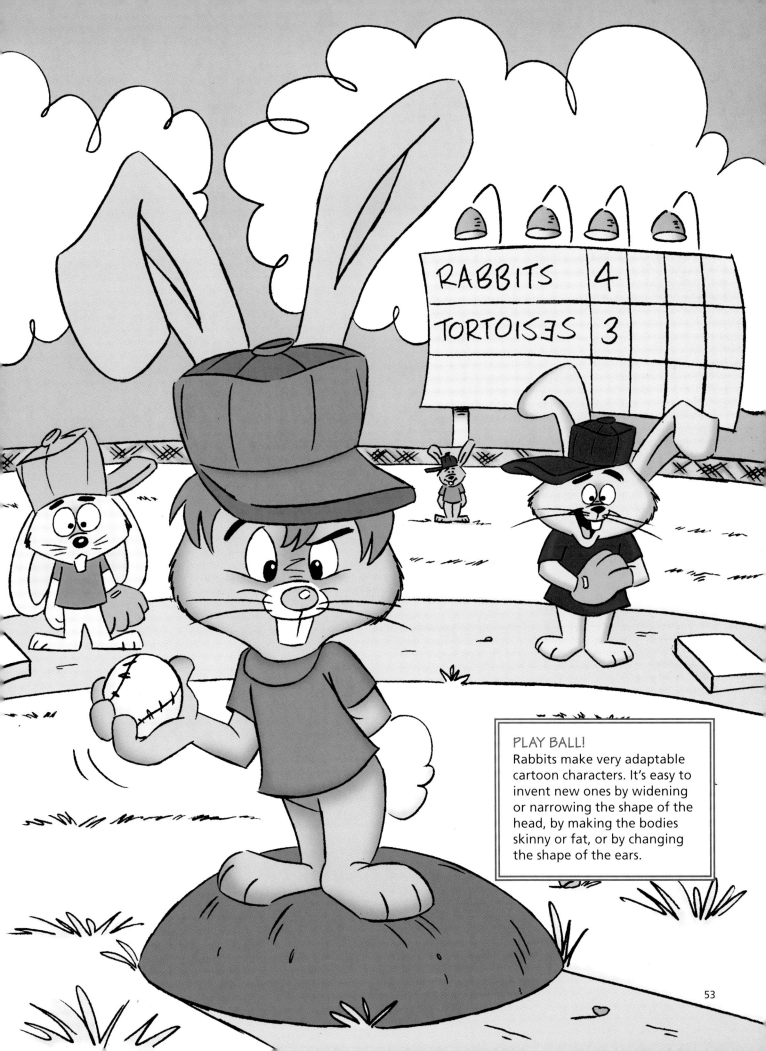

RABBITS 4
TORTOISES 3

PLAY BALL!
Rabbits make very adaptable
cartoon characters. It's easy to
invent new ones by widening
or narrowing the shape of the
head, by making the bodies
skinny or fat, or by changing
the shape of the ears.

53

Bunnies in Motion: Bunching and Stretching

When an animal leaps forward, it first coils up like a spring. This creates the energy to thrust forward. When coiled, the body *bunches* up and becomes shorter in length. As it springs forward, it *stretches* and elongates. Then, it bunches up again upon impact. Note how the head tilts back a little as the animal lands.

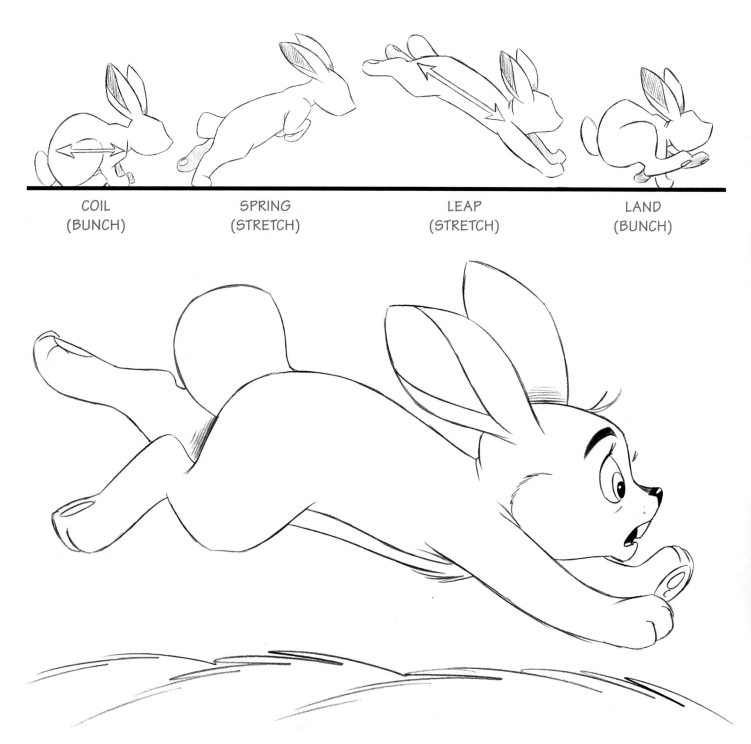

| COIL
(BUNCH) | SPRING
(STRETCH) | LEAP
(STRETCH) | LAND
(BUNCH) |

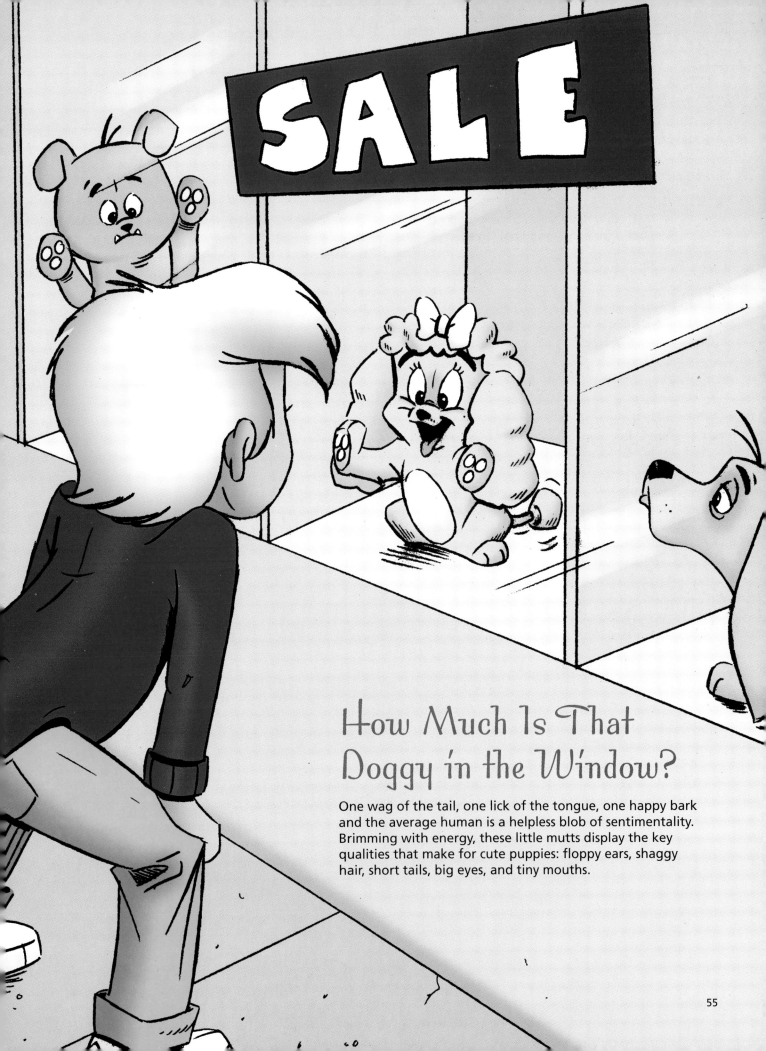

How Much Is That Doggy in the Window?

One wag of the tail, one lick of the tongue, one happy bark and the average human is a helpless blob of sentimentality. Brimming with energy, these little mutts display the key qualities that make for cute puppies: floppy ears, shaggy hair, short tails, big eyes, and tiny mouths.

Purebred Puppies

COCKER SPANIEL

The cocker spaniel is known for its sweet disposition, gentle eyes, and long flowing ears. Compared to many other breeds, it has a rather high forehead and is usually well groomed, if just a bit scruffy. The cocker spaniel puppy should look upscale, as if its owner lives in an expensive apartment building in New York City.

OLD ENGLISH SHEEPDOG

There are eyes on this face, but you'd never know it by looking at this pup. Note the shaggy upper lip and paws. The tail is docked—cut off at the tip, usually for show purposes—a practice I personally find disturbing. However, if you're going to draw a character that's recognizable, you should draw the most common variety, hence the docked tail.

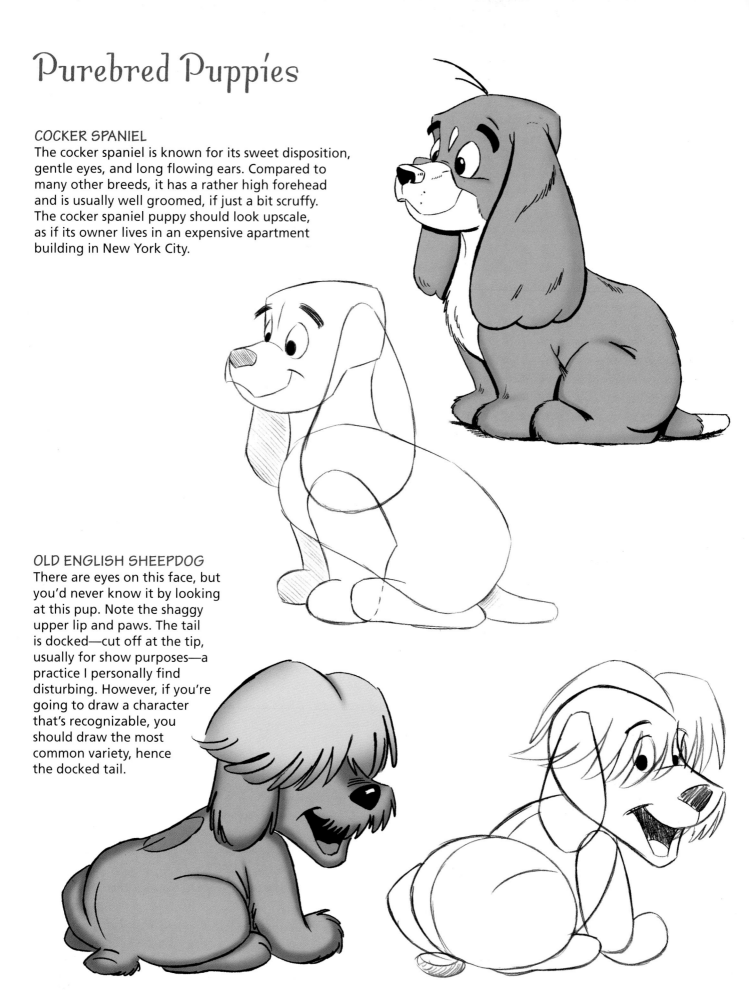

POODLE

What is it with poodle owners? Do they really think those haircuts look good? Nonetheless, these intelligent little puppies should always look pampered. Exaggerating the length of the ears and the naturally curly pouf of hair on this diminutive pup emphasizes its tiny stature. And, note that that's *hair*, not *fur*. Most dogs have fur, but poodles and a few other breeds have hair. That's good news for all you allergic types, since hair usually doesn't trigger allergic reactions the way fur does.

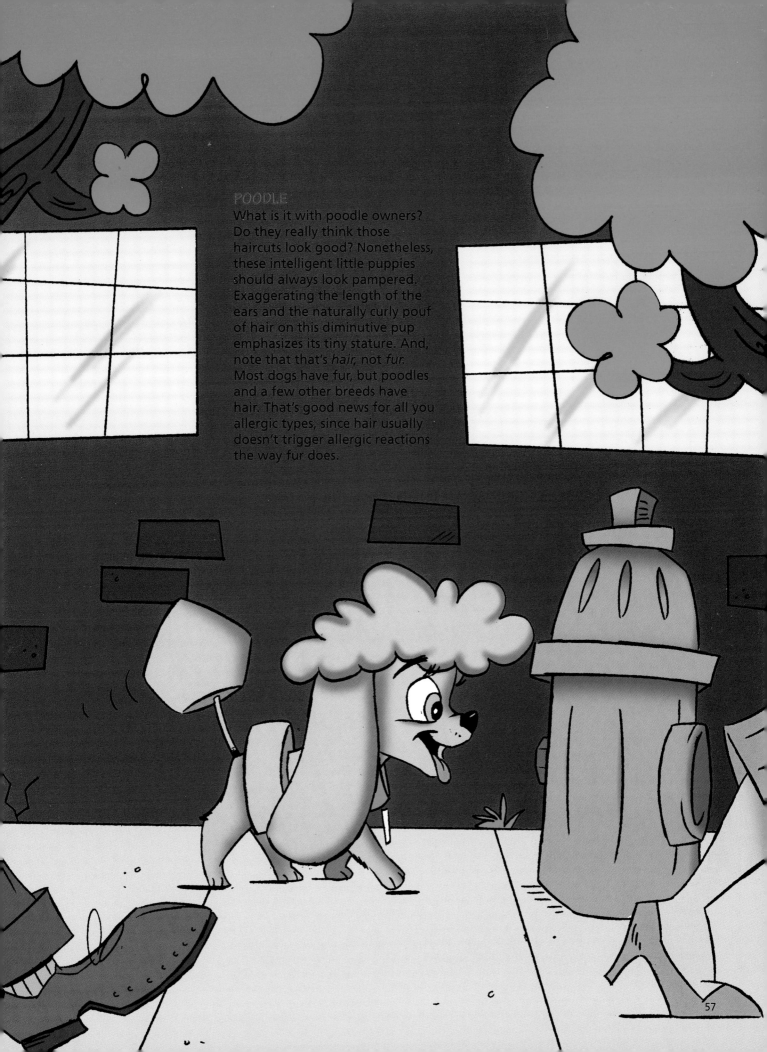

BULL TERRIER

The bull terrier is a funny-looking dog. It has pointy ears and facial features that are close together on a large head. The body is quite muscular, even in pups, but gives the impression of being a bit pudgy. This is one of the breeds referred to as a pit bull, and it can be ferocious, even dangerous, despite its sometimes small size.

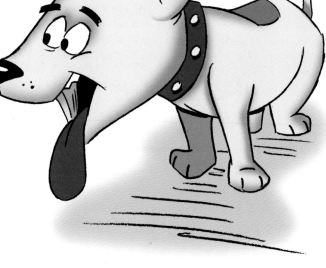

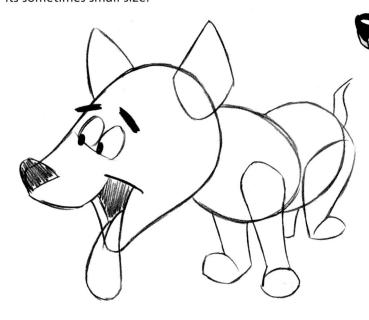

BLOODHOUND

This droopy puppy is a real sweetheart. The bloodhound's long floppy ears, wrinkled brow, and long flews (upper lip flaps) give the breed a distinctive look. It's also a long-bodied dog with loose skin and big paws, even as a pup.

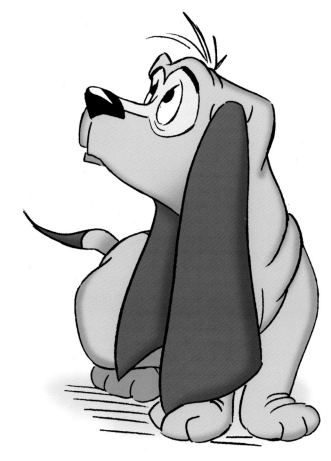

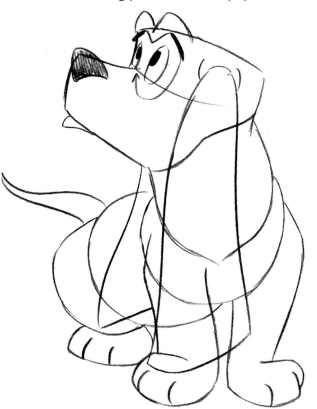

Mutts, Mutts, and More Mutts!

Mutts are fun to draw because you get to invent your own special breeds. The only rule about designing mutts is that they should look like good-natured "bad-boys" with devil-may-care attitudes. Remember, mutts aren't owned by the rich and famous, who prefer purebreds to reflect their good taste. And, mutts aren't owned by people in the country either, who want specific breeds of working dogs. Mutts are city dogs that survive on the streets by using their wits, or by hamming it up for sympathy.

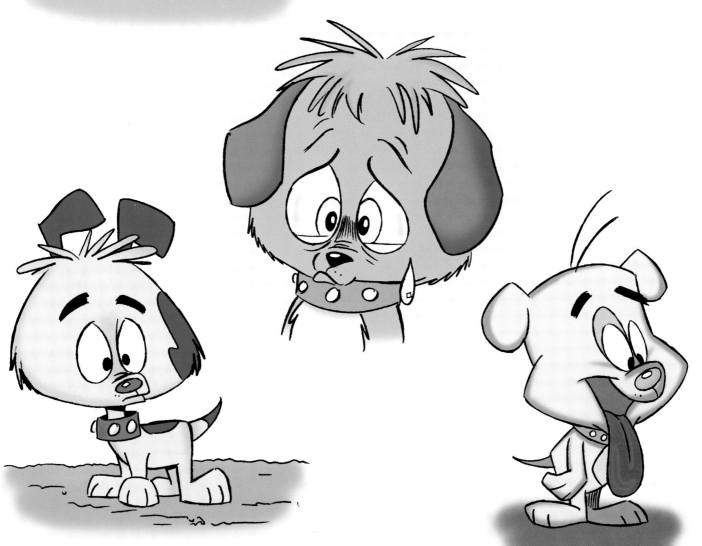

Cute Little Fur Balls

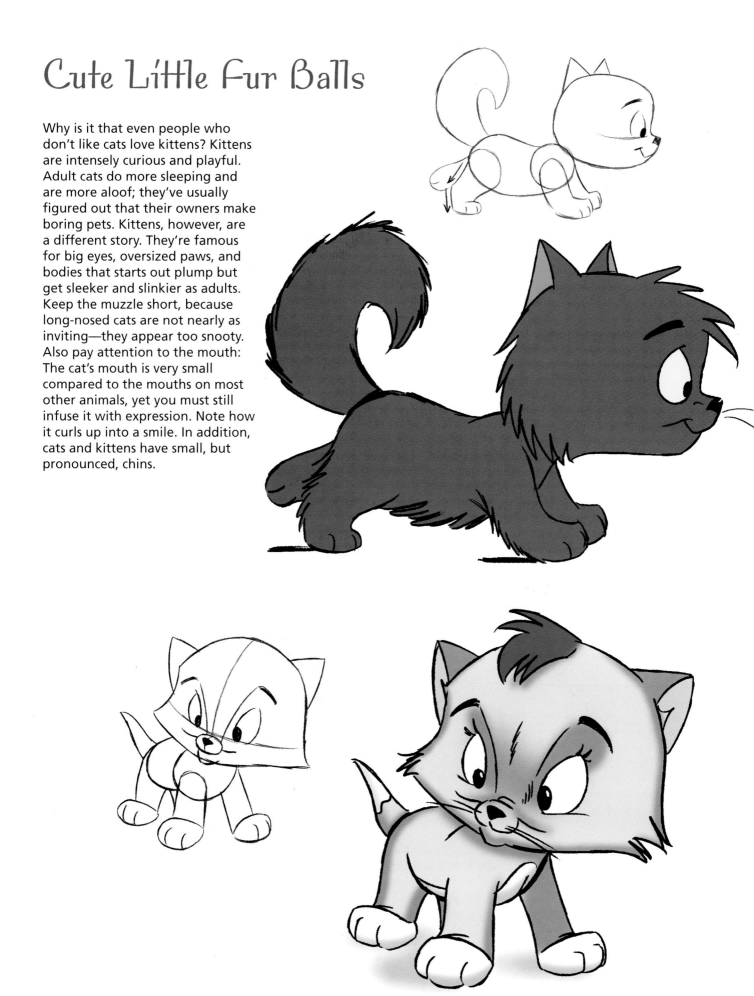

Why is it that even people who don't like cats love kittens? Kittens are intensely curious and playful. Adult cats do more sleeping and are more aloof; they've usually figured out that their owners make boring pets. Kittens, however, are a different story. They're famous for big eyes, oversized paws, and bodies that starts out plump but get sleeker and slinkier as adults. Keep the muzzle short, because long-nosed cats are not nearly as inviting—they appear too snooty. Also pay attention to the mouth: The cat's mouth is very small compared to the mouths on most other animals, yet you must still infuse it with expression. Note how it curls up into a smile. In addition, cats and kittens have small, but pronounced, chins.

Hints for Drawing Kittens

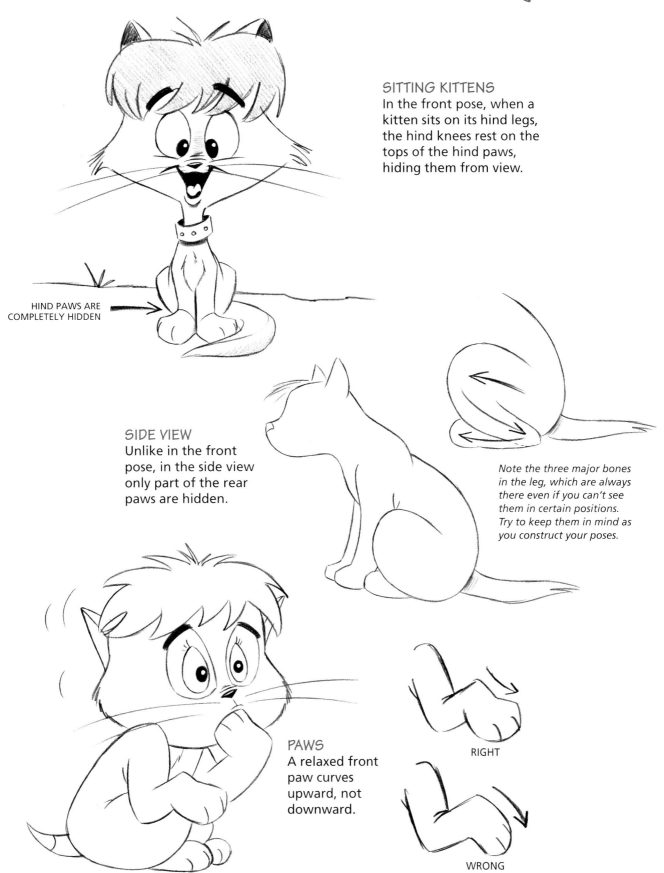

SITTING KITTENS
In the front pose, when a kitten sits on its hind legs, the hind knees rest on the tops of the hind paws, hiding them from view.

HIND PAWS ARE
COMPLETELY HIDDEN

SIDE VIEW
Unlike in the front pose, in the side view only part of the rear paws are hidden.

Note the three major bones in the leg, which are always there even if you can't see them in certain positions. Try to keep them in mind as you construct your poses.

PAWS
A relaxed front paw curves upward, not downward.

RIGHT

WRONG

Mice

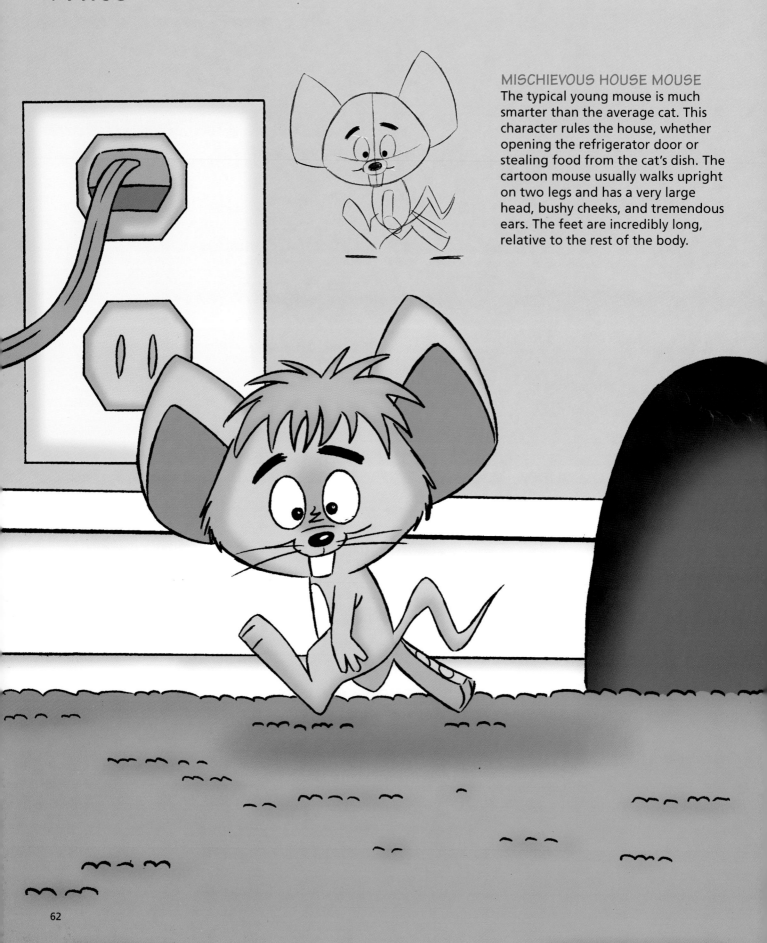

MISCHIEVOUS HOUSE MOUSE

The typical young mouse is much smarter than the average cat. This character rules the house, whether opening the refrigerator door or stealing food from the cat's dish. The cartoon mouse usually walks upright on two legs and has a very large head, bushy cheeks, and tremendous ears. The feet are incredibly long, relative to the rest of the body.

TIMID HOUSE MOUSE

This little character is more of a "real" mouse in appearance, temperament (nervous), and posture than the mischievous house mouse (opposite). Large eyes and a shock of hair give it a cute appearance. And, since this baby mouse is already somewhat realistic looking, I prefer to leave out the long teeth, which would make it seem less cute and more rodentlike.

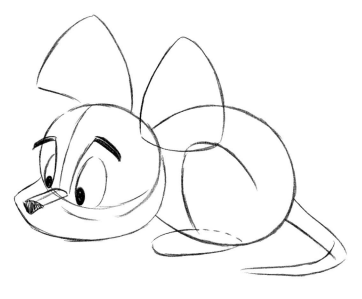

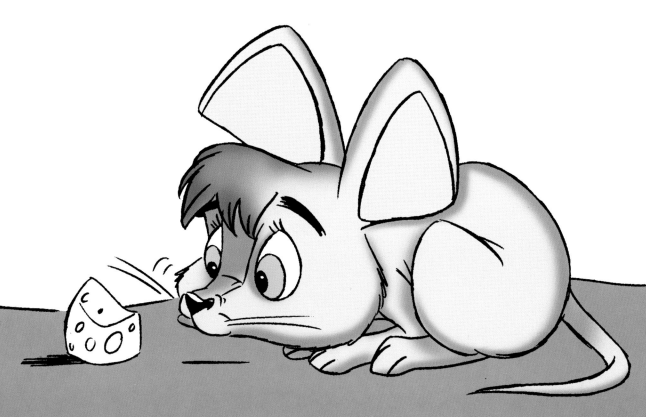

INDEX